THE ALEX ROSS MARVEL COMICS SUPER VILLAINS POSTER BOOK

ABRAMS COMICARTS
NEW YORK

In Memory of Steve Ditko

A MARVEL VILLAINS MURAL

By Alex Ross

Following up on the previous mural of Marvel heroes I created in 2019, a version with the same scope applied to Marvel villains seemed like an exciting idea. The goal of having a life-size mural of these figures for Marvel's New York offices has shifted to the greater usage in print and product application. Since I create each of the figures separately, they can be used on covers, calendars, standees, and poster book pages, so their flexibility is good for multiple purposes.

Intellectually, the ambition to draw upon an equal number of villains to heroes was not one I initially had. It was a little intimidating at first since I worried that a true focus on key famous super villains would likely pile up more adversaries for one hero in particular.

And that is exactly what happened, because the most well-known bad guys for Marvel are primarily from the Spider-Man comic books, and—interestingly enough—most are conceived and designed by the same person, Steve Ditko. Spidey's rogues gallery is not often the most cosmic or world-threatening, but they have a relatable appeal and simple, conceptual branding. Most of his enemies are based on an animal of some variety and have definition that is easy to interpret.

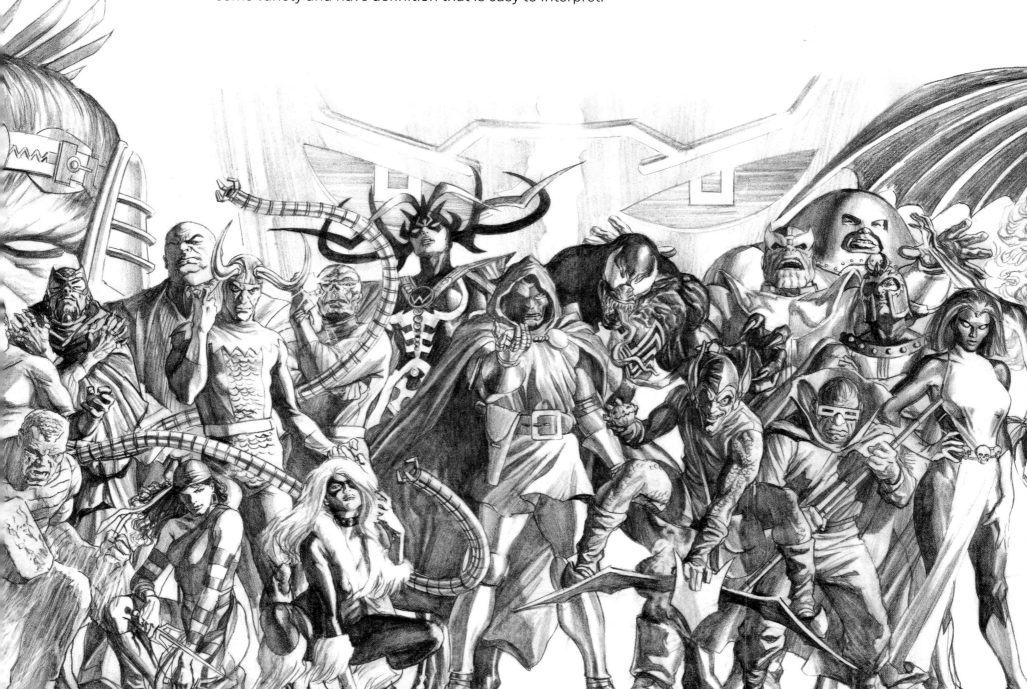

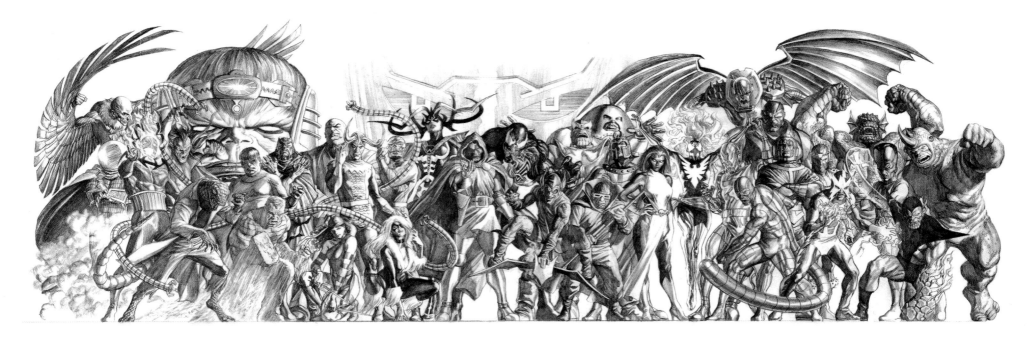

Generally, the lineup of other characters I chose are adversaries for the Fantastic Four, the X-Men, Captain America, Thor, the Hulk, Iron Man, and the Avengers. Just about every matchup of villain to hero has happened over the years, and very often the good guys share their archcriminals with one another.

With my selection, there is a limited reach coming from my own sense of history and evaluation of which characters to include. Those who made this cut were determined based upon repeated appearances throughout the last several decades, and by cultural impact. All of my choices can be debated, and in this kind of situation, I'm guaranteed to let somebody down.

The general process for doing this second "mural" of figures for Marvel is the same as I did the first time. I crafted a first-take sketch based upon a center lineup to determine who the central focus would be. In this case, there was no question about who the lead villain would be—Doctor Doom. Once I was bracketing him with the Green Goblin, Red Skull, Loki, and other top-level bad guys spreading out from the center, I began to see how well I was representing varied villains who plague more than just one or a few heroes. The unifying element of Galactus' large head fading into the background was a departure from the heroes' mural, but he was too vast in volume to incorporate casually. I knew I would need to paint a full-size Galactus head, with helmet horns complete, to have just for this usage. His painted scale was in proportion to my normal twenty-seven- to twenty-nine-inch-tall figure portraits, making his head over five feet in height.

Surprisingly, the sizes of the various figures are far larger than in the previous mural. The oversize Hulk-sized villains are numerous, and giant heads like MODOK or Galactus are bunched up alongside extended winged figures such as the Vulture and Annihilus. Including the full reach of Doctor Octopus' arms made for one of the largest pieces I've ever produced.

The posing and more pronounced gesticulation of the Marvel villains was intended to illustrate their attitude and energy. Each figure was designed to fit where they balanced against another character and showed a certain amount of their individuality. I went a little over the count from the Marvel heroes to make this assembly (thirty-seven as opposed to thirty-five), just for the reasons of what felt right. And in case you're wondering, I do regret omitting at least one person. If I didn't bother to overthink how people view his signature slipper shoes, I should have definitely included Kraven the Hunter. He is the Ditko design that definitely completes the lineup of Spider-Man's most-valued adversaries and is one of the original Sinister Six. By the time you're reading this, I'll have probably painted him for my own benefit and some potential printing in one form or another.

As this Marvel super villains poster book proves, the extent of who else can be shown never ends.

THE POSTERS

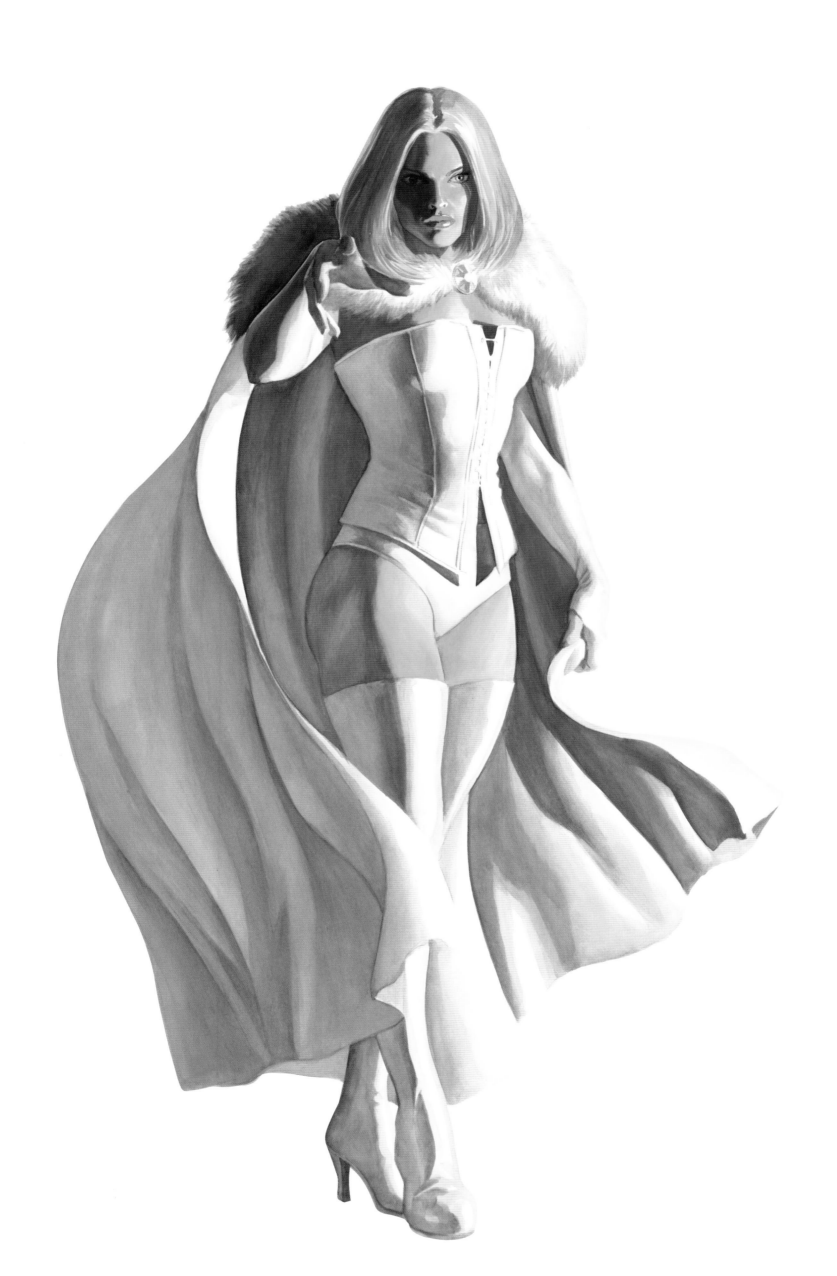

EMMA FROST

Most of what defines Emma Frost came through in her original appearance as the telepathic powerhouse of the Hellfire Club in the X-Men storyline that gave us Jean Grey's transformation into the Dark Phoenix. The Hellfire Club was a fetishistic collective of eighteenth-century English fashions for the men and bordello-like attire for the women. As the elite secret society of this club had kidnapped Jean Grey and mind-controlled her into the role of their Black Queen, her White Queen counterpart was Emma Frost. The unique features of Emma were meant to be attractive but severe, with a hairstyle that accentuated an angularity to her face. The basic revealing nature of Emma's white clothes evokes a definite confidence and sex appeal that is meant to be intimidating before she exerts her mutant powers. Regal and impractical, Emma Frost cuts a figure in action that doesn't need to dress for any other occasion than the impression she wants to make.

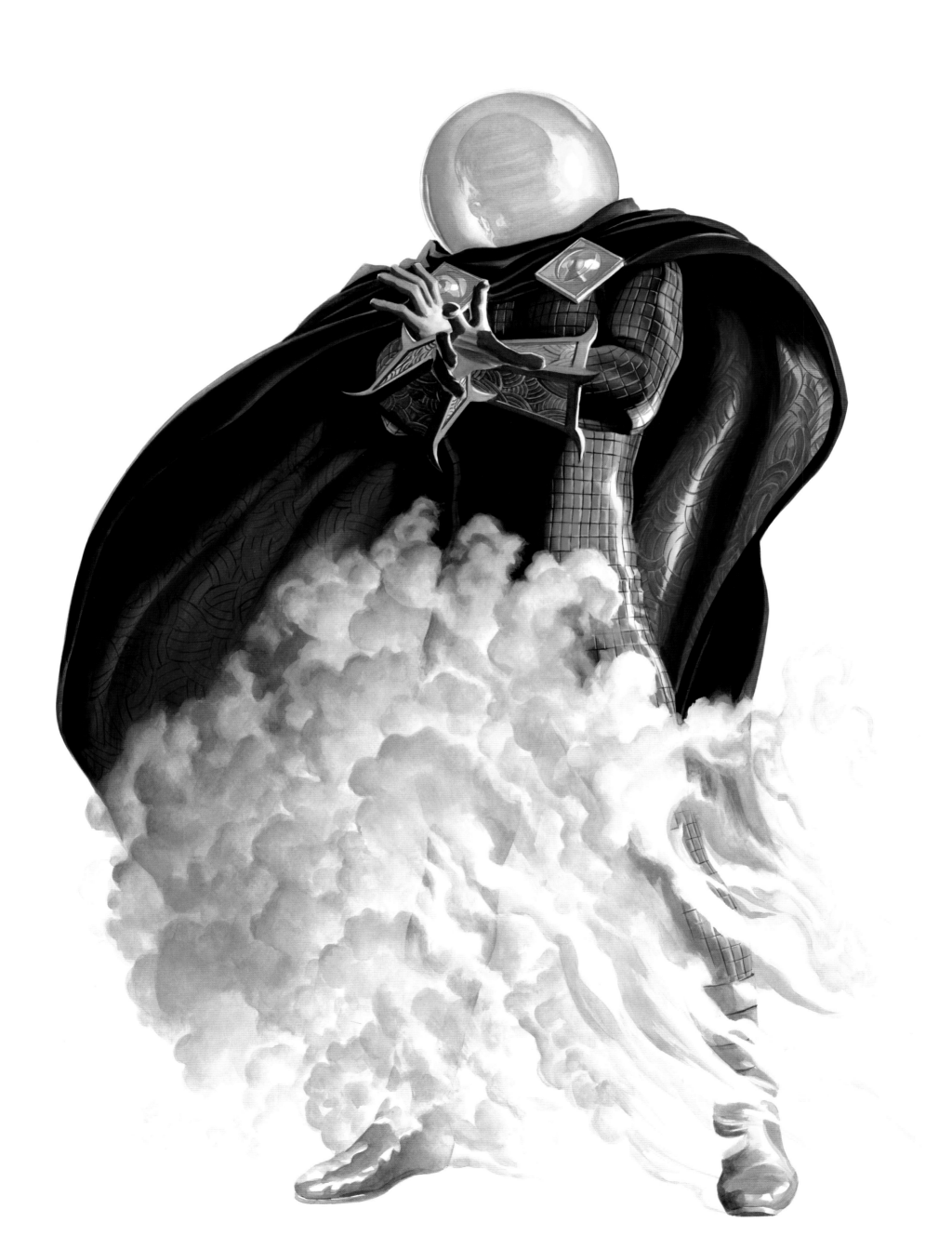

MYSTERIO

One of the many Spider-Man villain designs that screams the hand of his co-creator, Steve Ditko, is Mysterio. The graph pattern over his green bodysuit seems like a kindred look to Spider-Man's webs. The eye clasps and pointed gauntlets are pure Ditko elements found throughout his costume designs in the mystical worlds of Doctor Strange. The interior pattern of the cape is yet another area that shows a tremendous flourish of detail, often overlooked by later artists interpreting the suit. The mystery of what the shadow within the goldfish bowl-like helmet is indicating was always a haunting part of Mysterio's look. Because I think of his real face under that hood, I endeavored to hint at his likeness. The addition of smoke at his feet to obscure his comings or goings is a part of his overall aesthetic, which is to create realistic illusions and confound how he is fully perceived.

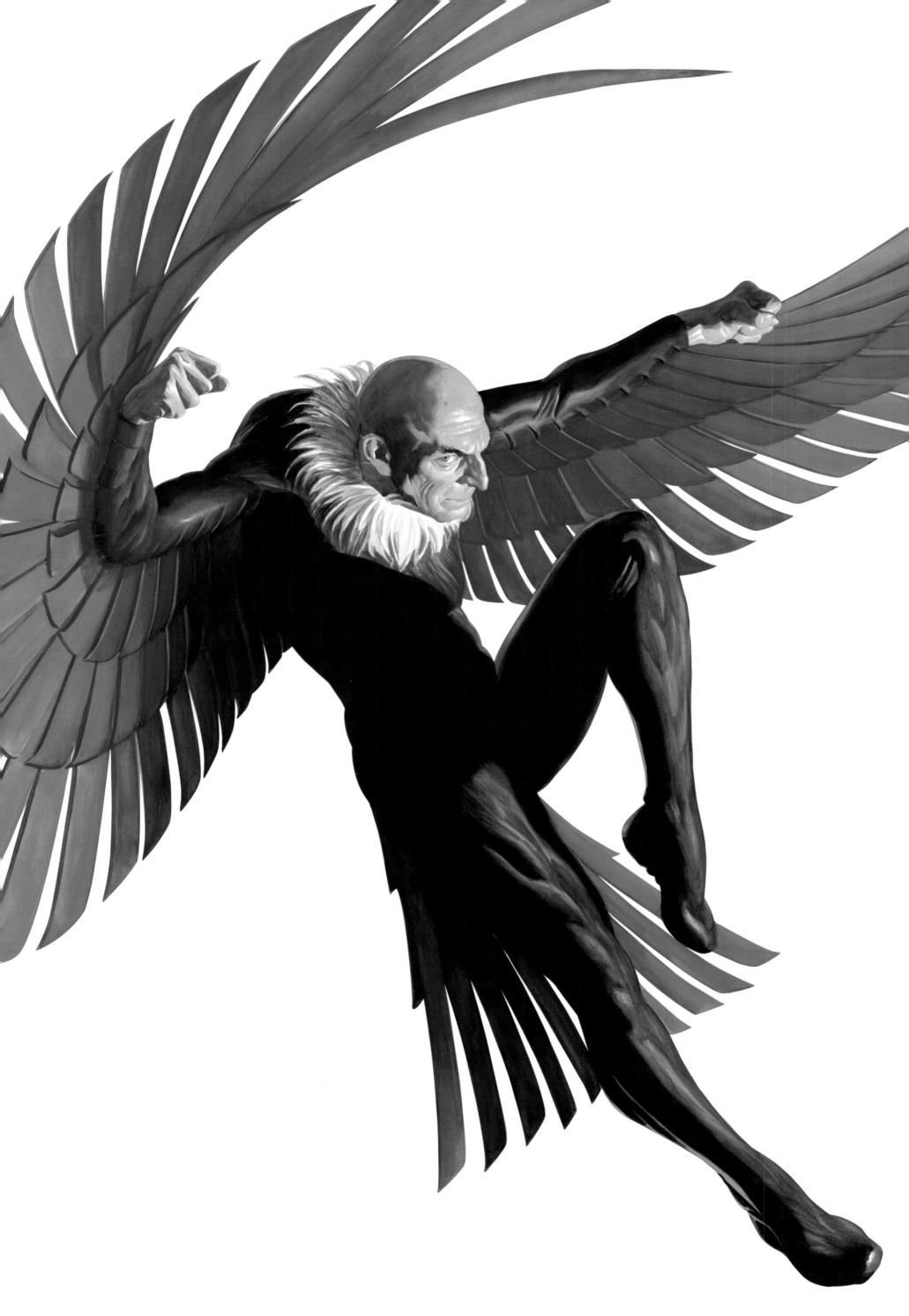

THE VULTURE

The earliest Spider-Man villain to really make his mark was the Vulture, who first appeared in *The Amazing Spider-Man* no. 2. His look was distinctive for a man with artificial wings who himself resembled the animal he patterned his identity after. It was an essential aspect of him to have the aged, wrinkled bald head with a pronounced beak-like nose and weak chin. Even though this design would seem to put his body in some vulnerable exposure, his uncovered head is a clear part of how he communicates his mood and personality. His look makes the reader feel both his creepiness and humanity, which is the way we should view the character.

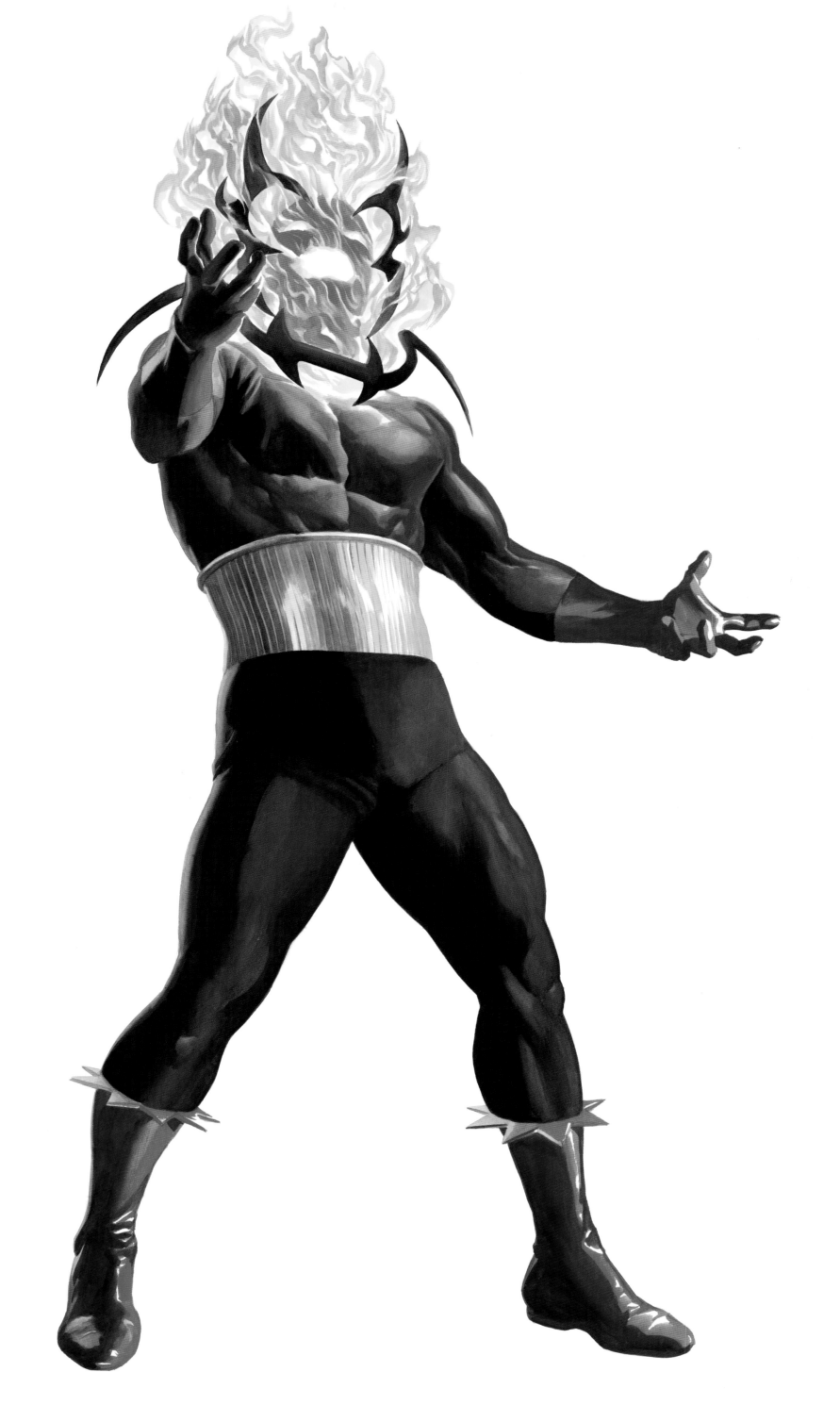

DORMAMMU

The flame-headed archnemesis for Doctor Strange always struck me as a cousin to the classic Human Torch design. The character did not begin quite that way when his earliest appearances had his head colored in a blue hue with a smoky contour halo. As he developed, his clothing became more formfitting, which may have been creator Steve Ditko's intention to craft a fisticuffs-ready antagonist whose head started to resemble the Marvel flame-lined house look. Characters from Ditko's other-dimensional worlds would often expand his fashion design reach to its most "Ditkoesque."

A great era of interpretation to Dormammu's unique and fearsome presence came from artist Gene Colan's run on the *Doctor Strange* book in both the late 1960s and the mid 1970s. Whether showing Dormammu's form as a giant or using overly expressive gesticulation, Colan rendered the villain with great drama and menace. In selecting a look for my illustration, I portrayed the laughing quality I remembered from Colan's work with some of the collar and cuffs from Ditko's adornment.

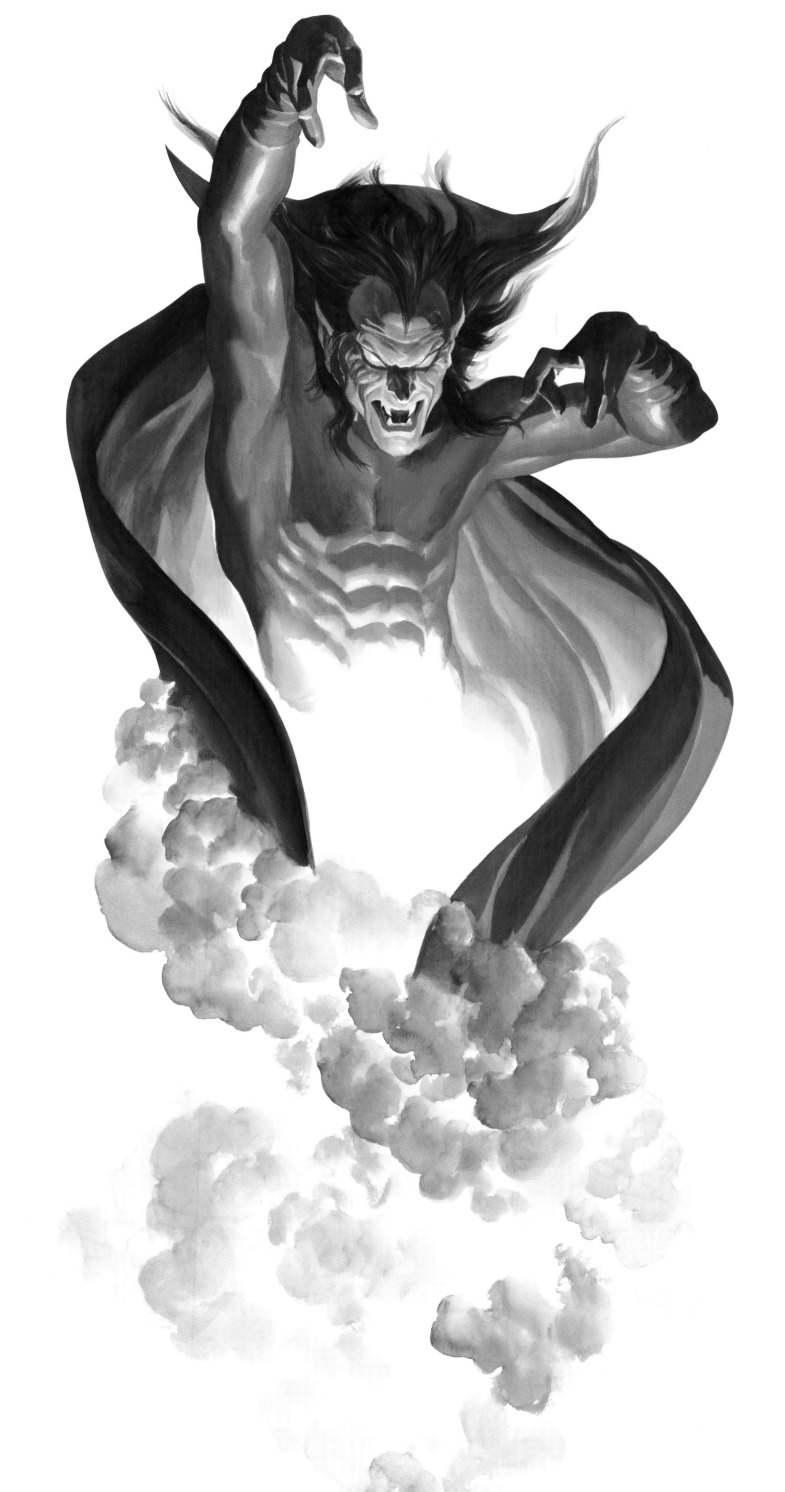

MEPHISTO

Most of what makes this Marvel take on the devil archetype so arresting is the elegant rendering of artist and co-creator John Buscema. Buscema's work on *Silver Surfer* is an absolute apex of all his four decades at Marvel Comics, and the issue introducing Mephisto [*Silver Surfer* no. 3, December 1968] is a lush triumph of dynamic figure drawing that no one pulled off quite the way John did. The traditional devil trappings of horn, pitchfork, and goatee were avoided in favor of the angular features, hair, and lighting used to make Mephisto fearsome and compelling. Other demons of comparable importance were added over the years, including a direct "Satan" himself in the *Son of Satan* comic, but none compared to the impression Buscema's Mephisto left behind.

The use of the shortened Mephistopheles name made it easier to feature the villain over the years, as a direct "devil" could inspire criticism of potentially insensitive depictions of figures from religious beliefs.

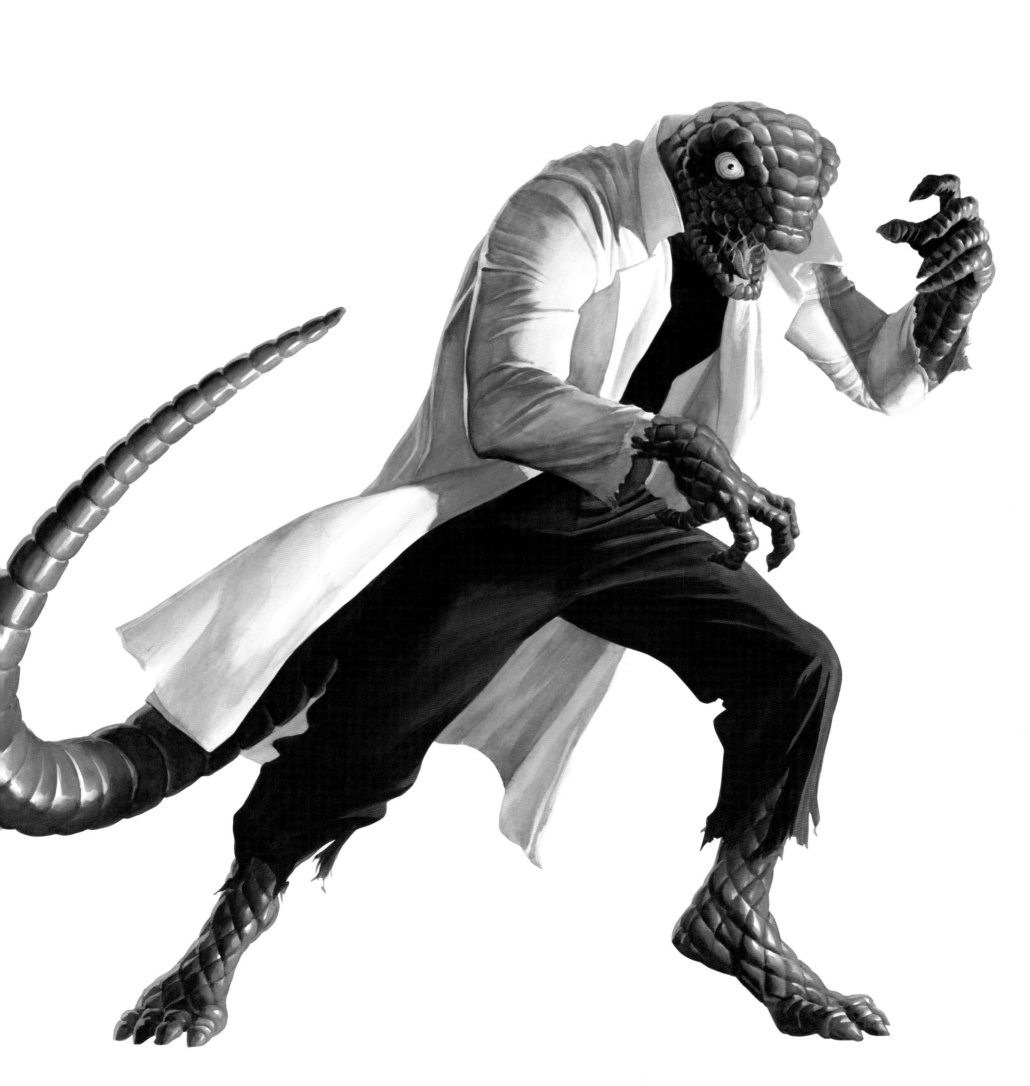

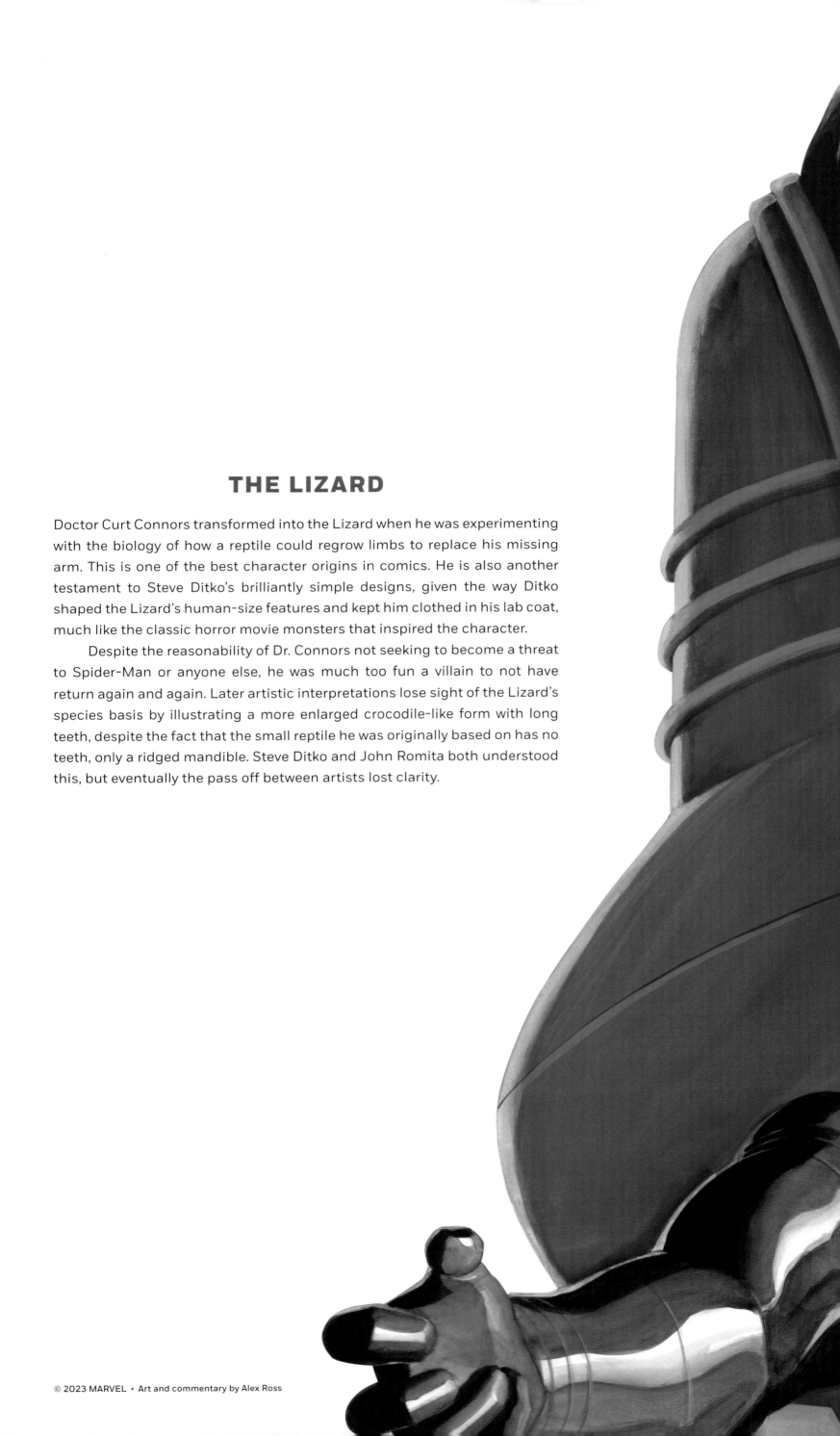

THE LIZARD

Doctor Curt Connors transformed into the Lizard when he was experimenting with the biology of how a reptile could regrow limbs to replace his missing arm. This is one of the best character origins in comics. He is also another testament to Steve Ditko's brilliantly simple designs, given the way Ditko shaped the Lizard's human-size features and kept him clothed in his lab coat, much like the classic horror movie monsters that inspired the character.

Despite the reasonability of Dr. Connors not seeking to become a threat to Spider-Man or anyone else, he was much too fun a villain to not have return again and again. Later artistic interpretations lose sight of the Lizard's species basis by illustrating a more enlarged crocodile-like form with long teeth, despite the fact that the small reptile he was originally based on has no teeth, only a ridged mandible. Steve Ditko and John Romita both understood this, but eventually the pass off between artists lost clarity.

MODOK

In most other hands, a character design like MODOK would look juvenile and cartoonish, but in Jack Kirby's hands, the Humpty Dumpty-like form is treated with weightiness and the distortion of an experiment gone wrong. The Mobile Organism Designed Only for Killing was a fearsome mutation engineered to have tremendous mental and energy-projection powers.

My first introduction to the villain was as a foe for the Hulk, where his large-headed form was equipped with a gigantic mechanical body that he could pilot around. This is a regular feature he would utilize before someone eventually brought him down.

The look of MODOK is one that hasn't changed too dramatically over the years, as it's a striking one that makes an impression today as much as he did when he was first revealed by the scientific criminal organization A.I.M. to fight Captain America in *Tales of Suspense* no. 93 (September 1967).

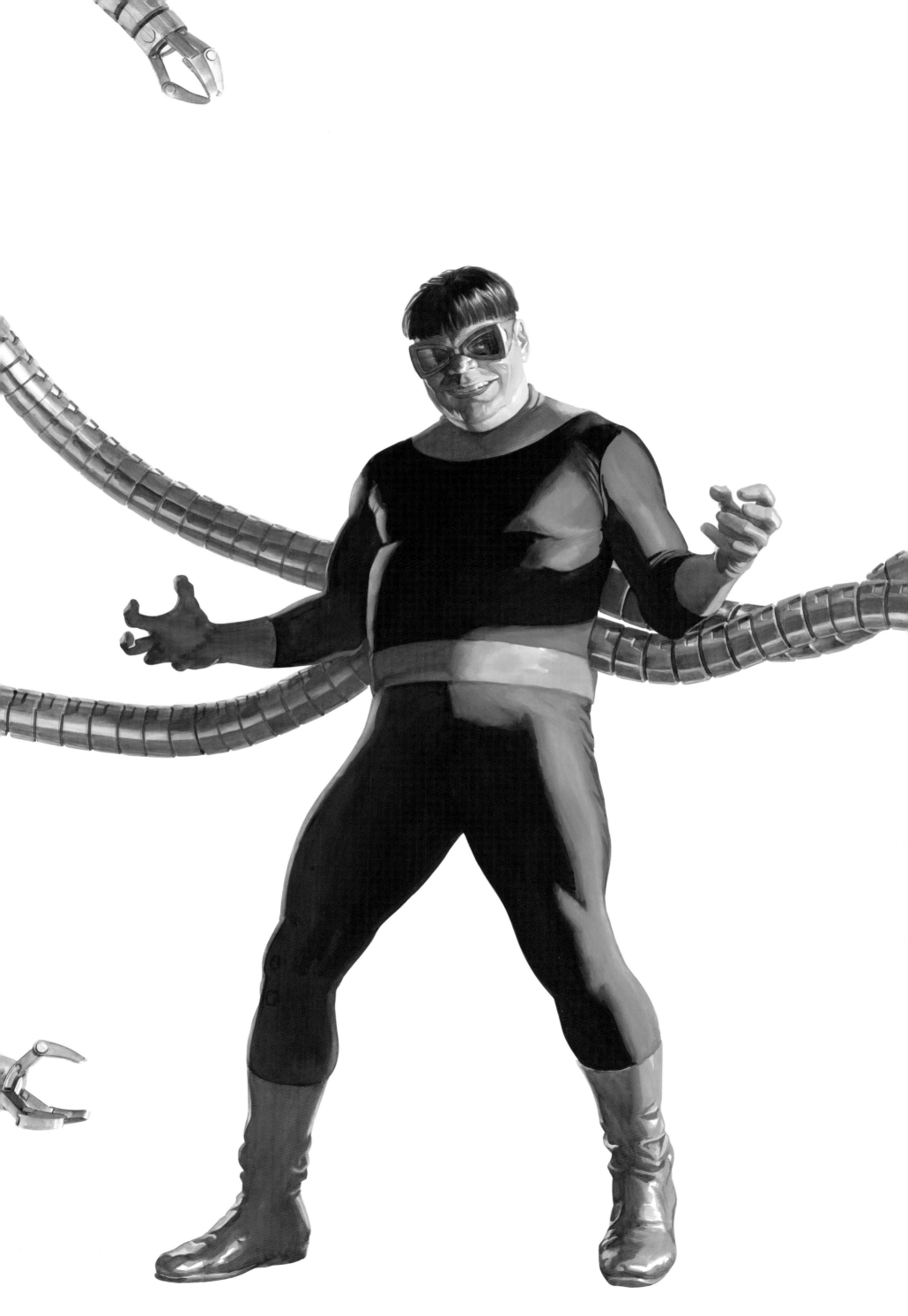

DOCTOR OCTOPUS

The character who may have been designed to be Spider-Man's lead archvillain was the brilliant Doctor Otto Octavius, a man aptly named for his experimenting with mechanical octopus-like arms. "Doc Ock," as he is nicknamed, was the greatest schemer of Spidey's rogues, often using his scientific genius to devise greater threats for his foe. He sometimes expanded his ambitions to include costumed henchmen and even large octopus-inspired vehicles.

One unique aspect of Doc Ock's design was to have a very distinctive facial structure, albeit always bespectacled, and a body type that wasn't a one-size standard for most comic book characters. For a time in the seventies, he was drawn with a more fit, muscular form, but much of his unique nature was subverted. Eventually, later depictions would return to Steve Ditko's original look as depicted here.

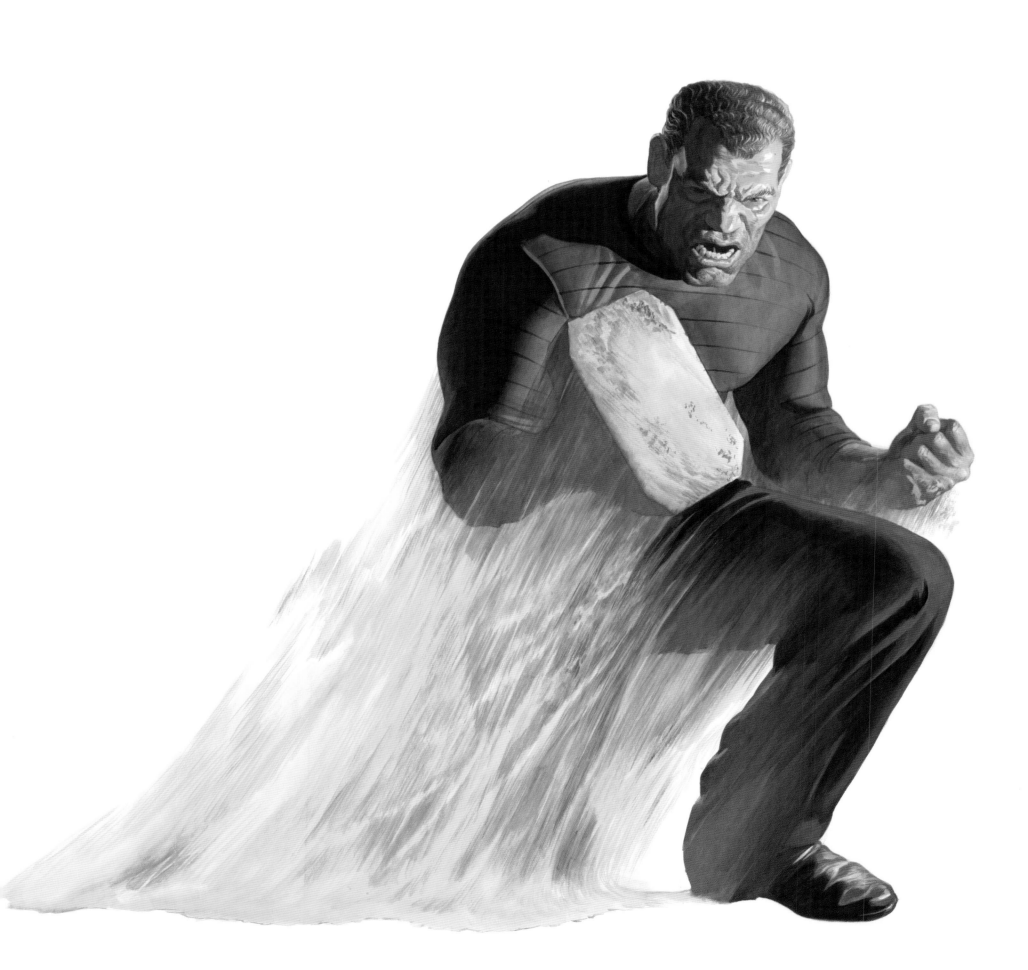

SANDMAN

Marvel's Sandman was a true distillation of the fabled name into an elemental power manifestation. Steve Ditko's design played his look as a striped-shirted convict who was transformed into living sand and could take the stretching-power dynamic into new and unsettling territory. The Sandman character seemed to be shared equally between the Spider-Man rogues gallery and that of the Fantastic Four, where he joined a team of villain counterparts called the Frightful Four. Jack Kirby seemed to equally like the character, as his rendering was consistent with the way Ditko crafted him. For a time, Sandman changed to a more armor-like costume of Kirby's design, but eventually other artists returned him to the "plainclothes" look he started with.

Sandman's signature green shirt may seem to establish a repetitive link with the first round of Spider-Man's villains who all wore green. Aside from the later-introduced Green Goblin, none of these characters had a reason to be green except that it was a contrast to Spidey's red and blue colors.

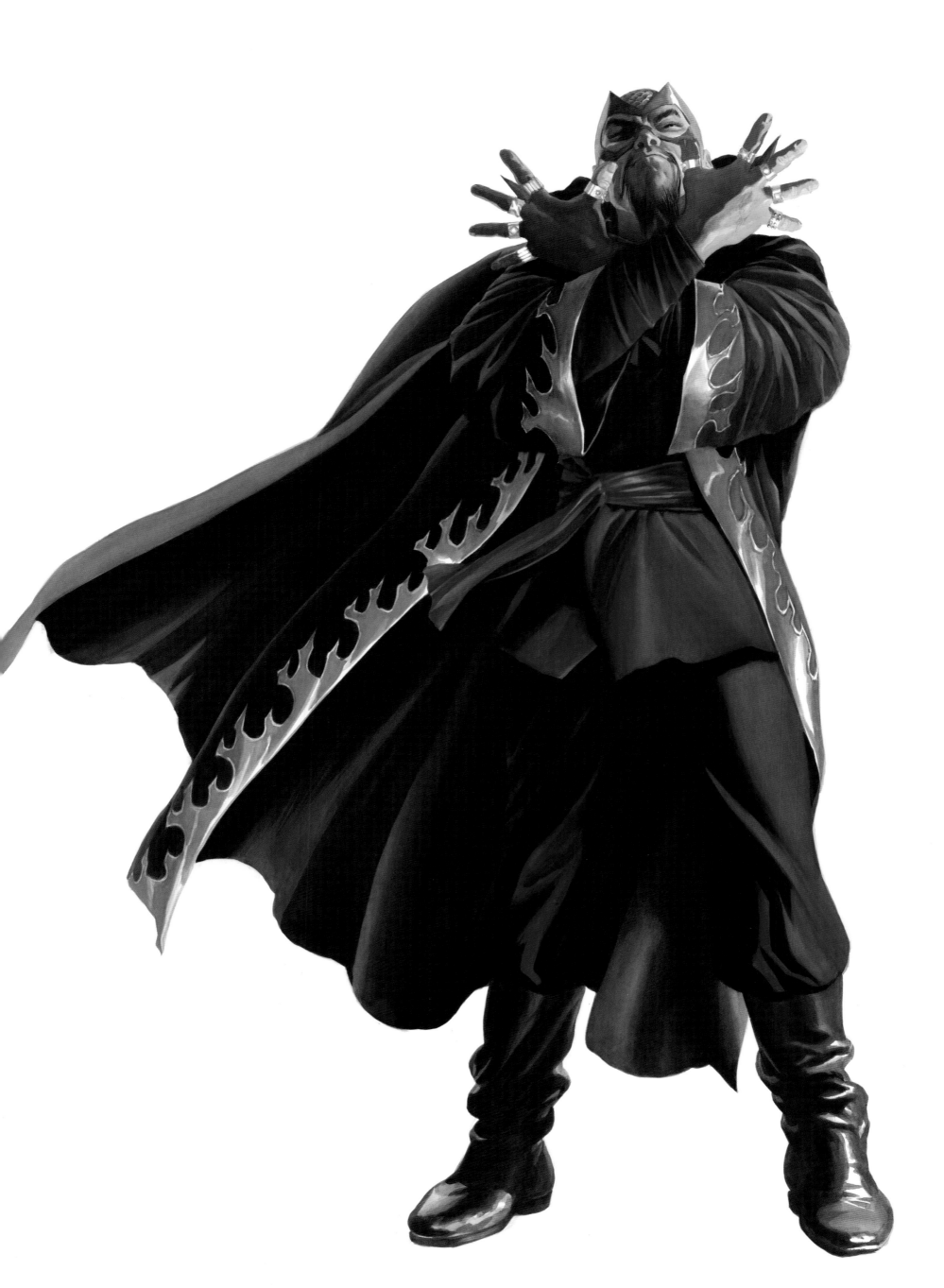

MANDARIN

The Cold War era birthed most of the cast of Iron Man's adventures, as he was supposed to be a figure of America's military and weapon capacity, drawing foreign and domestic threats to him which he could then subvert. No villain represented this cultural enmity more than the Mandarin, who sought to dominate the world, beginning with his homeland, China. His principal power was the alien-derived Ten Rings he wore, each of which had distinct forces they projected.

The first looks for the Mandarin were by Iron Man series artist Don Heck and were largely taken from historical Chinese robes, with the specific facial hair that used to be worn by older men. Other than the typical comic-style pointed masks, the use of an English language letter "M" on his chest is a clear oddity to his cultural specifics. The Mandarin has come to be revised repeatedly to display both more advanced fantastic armor and robes while also reverting to even more traditional clothes from centuries past.

I picked one of his earliest looks here, with layered, loose clothing that would later shift into long hanging robes.

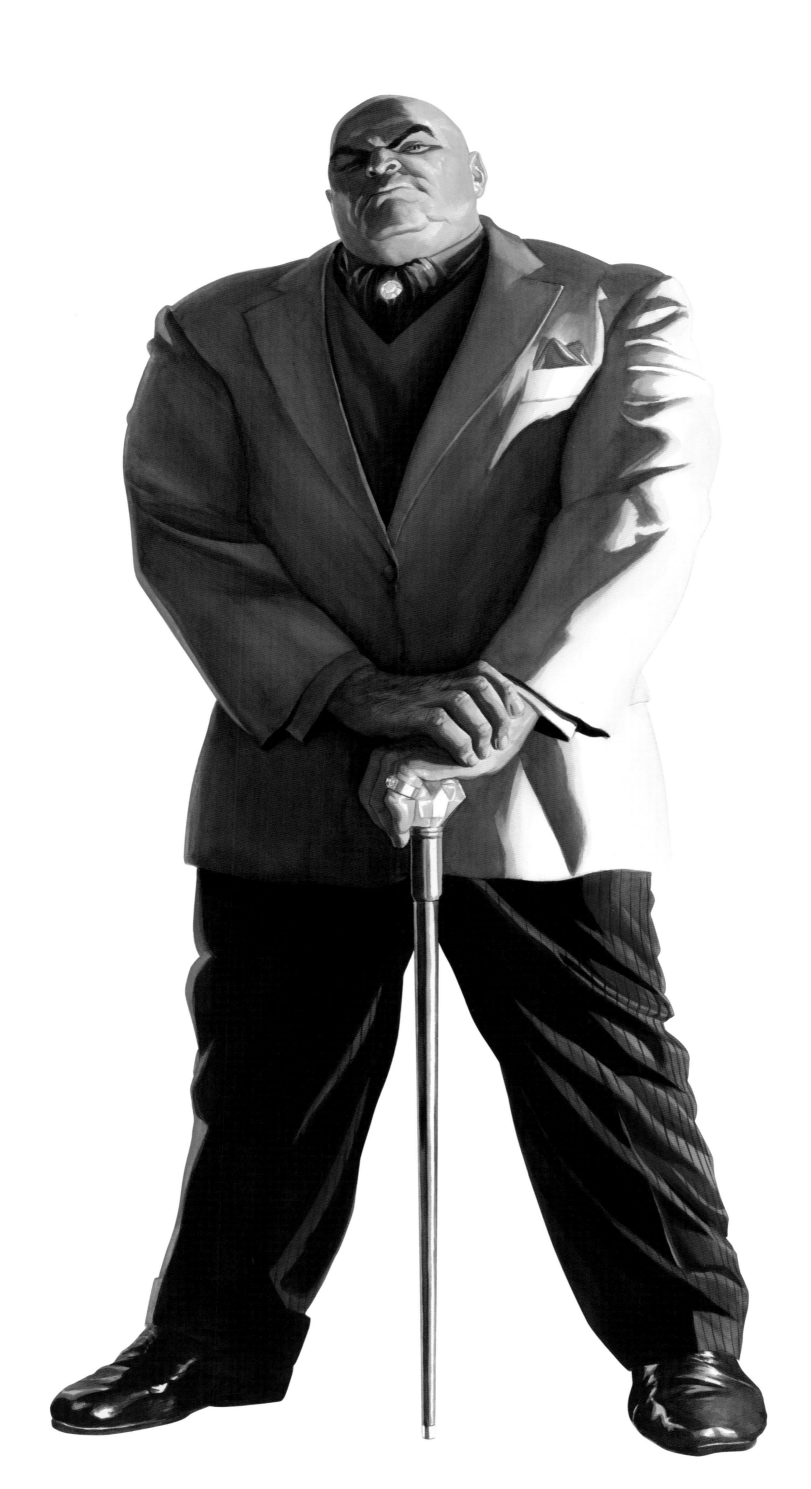

KINGPIN

I hope it is OK to say that when I met the Kingpin's co-creator and designer, John Romita Sr., I could see his features within that character. This would be exaggerated, of course, but the exact shape of Romita Sr.'s nose and facial proportions were visible to me in the face of this Hulk-size villain.

The nature of how we inform our work as artists most often incorporates our own features and overall body structure into the images we create, either consciously or subconsciously. I've looked for these details in other artists I meet who I might even have a mental impression of from their artwork before I've even seen them. John Romita Sr.'s definition of the Kingpin has barely changed over the years, with the exception that most people don't use the fashion of a neck scarf or ascot with a jewel in it.

Kingpin has also grown in height to make him an even more imposing figure than his original appearances as a foe for Spider-Man. Being a human-size Hulk wasn't good enough for everyone, and his overall silhouette increased to a magnificent size due to the painted interpretation by Bill Sienkiewicz in the Daredevil graphic novel *Love and War* by Frank Miller in 1986.

Kingpin represented a break from the traditional costumed (and often green) Spider-Man villains, and he would also embody the world of organized crime in New York City, grounding his stories in aspects of the real world that other antagonists never could.

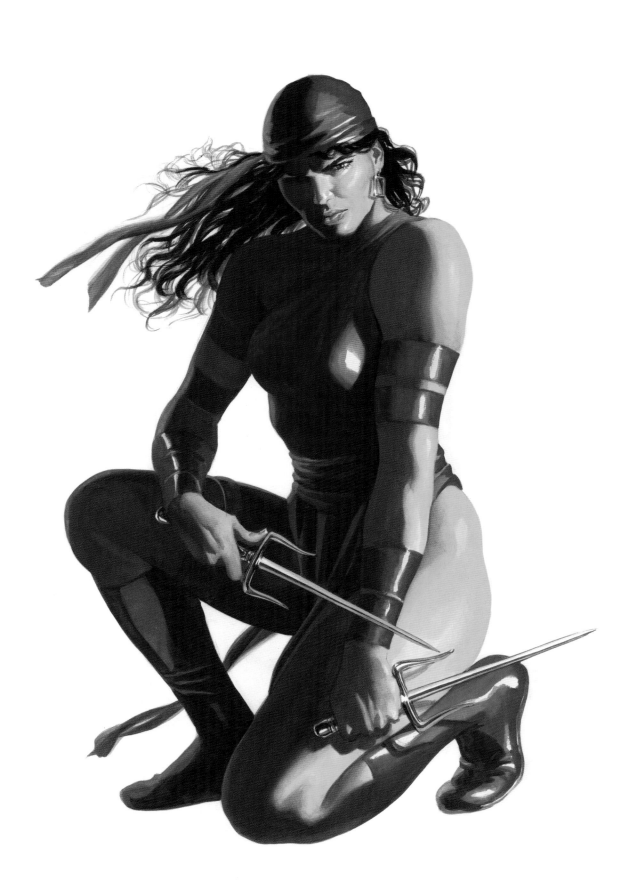

ELEKTRA

Elektra is the singular creation of artist/writer Frank Miller and is often seen as his most distinctive contribution to Daredevil lore—an antihero assassin who is redeemed through her death and rebirth. It was Miller who killed her, and after his star ascended to even greater heights, he returned to the title in 1990 to resurrect her in the graphic novel *Elektra Lives Again*, which is a great representation of the artist at the peak of his talent.

Elektra is a strong example of the Eastern mythology and ninja history incorporated into Western comics. Despite her colorful attire, she was a figure of stealth and murderous precision. Over the years, she has maintained her popularity within the super hero/villain firmament.

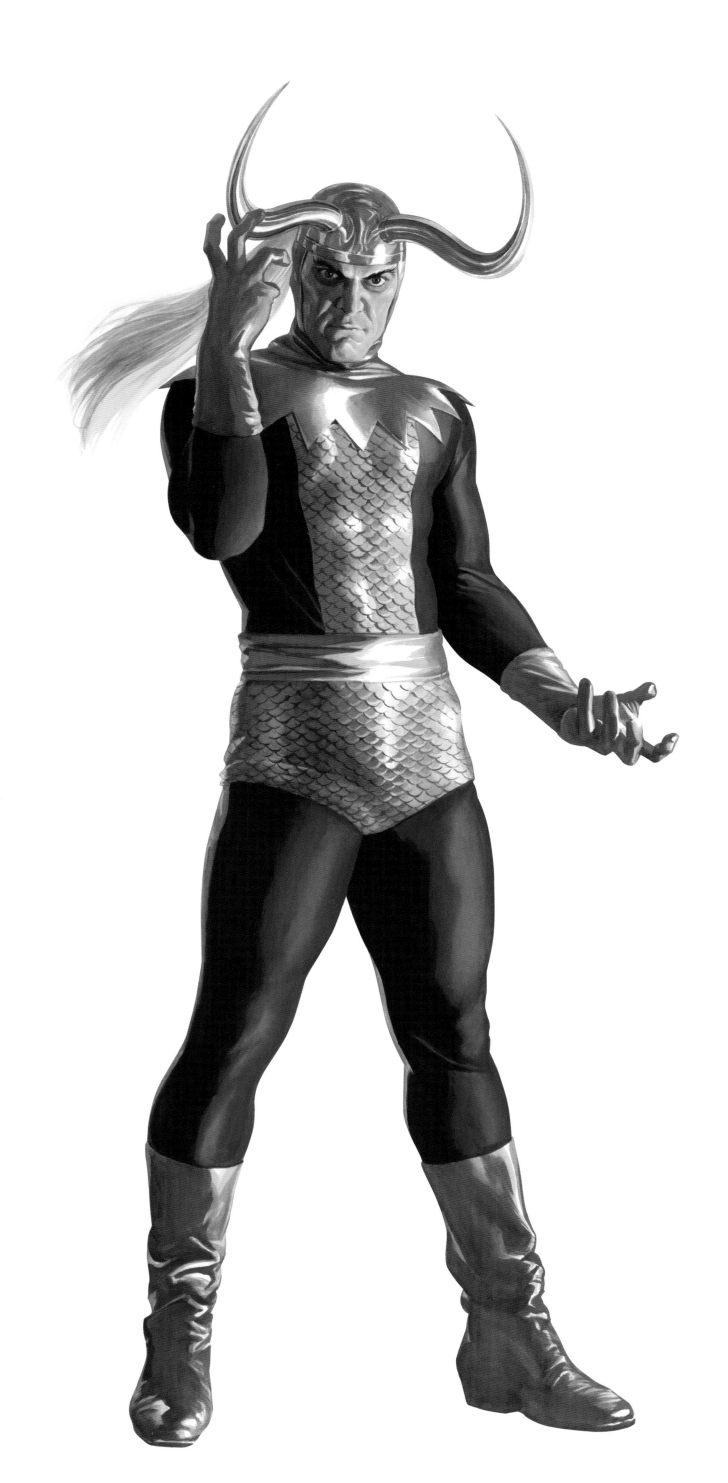

LOKI

The adopted brother of Thor stands as one of the most beloved figures of comics fandom, particularly for his contemporary portrayal in film and TV as a complicated adversary, but he had already persisted as a favorite villain in comics for decades. His legend from Norse mythology inspired engagement over centuries, leading to the interpretation by Stan Lee, Larry Lieber, and Jack Kirby for the *Thor* comic book series. With their alterations to the lore, the Asgardian siblings' rivalry seems to have forever redefined and overshadowed the original legends. (Loki was the blond one, actually.)

Loki's features were shaped by Kirby and later John Buscema in a classic movie villain mold, establishing an immediately sinister effect. The Loki of the comics almost never showed his dark hair but kept his scalp covered with gold-horned headgear, as a counterpart to his brother's silver-winged helmet. Never a primarily physical foe, Loki generally used his magic to manipulate others to do his bidding, devising countless plots to bedevil Thor in his bid to rule the otherworldly kingdom of Asgard.

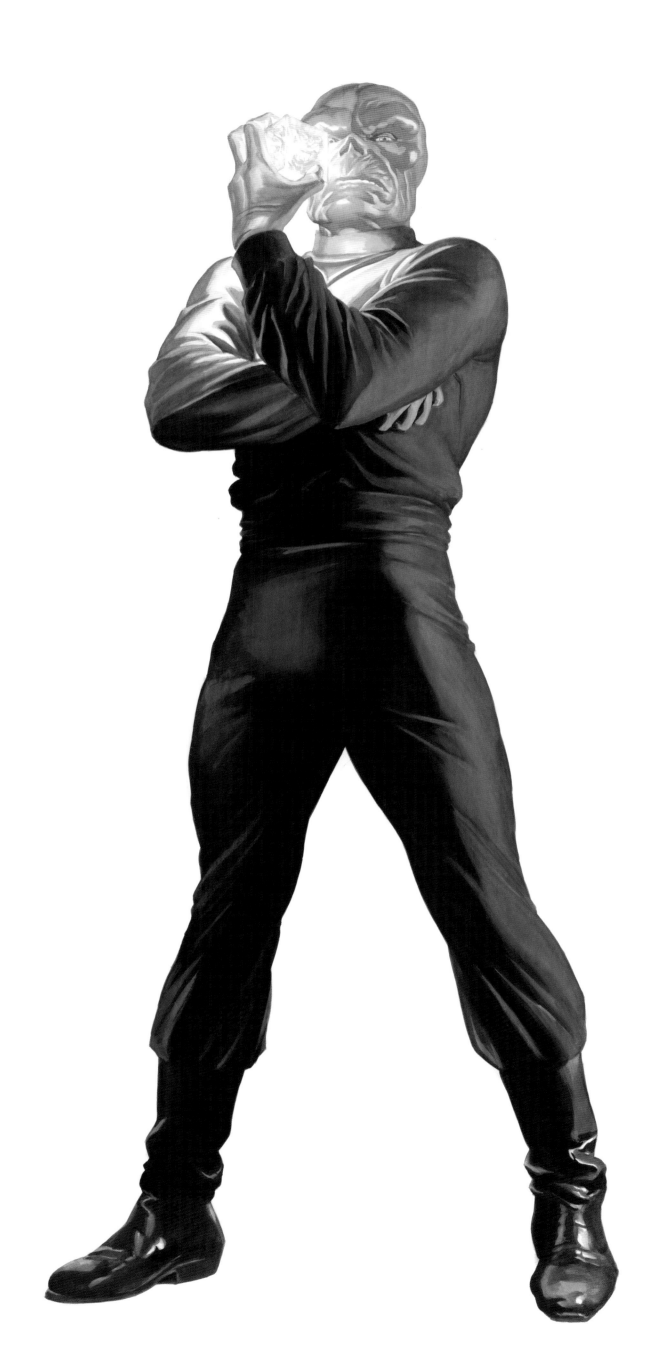

RED SKULL

The longest-running Marvel villain, the Red Skull premiered in the first issue of *Captain America Comics* in 1941. His presence can be seen in every decade that followed and is one of the few standout adversaries from Marvel's beginning as Timely Comics. Much like his archenemy, Captain America, the Red Skull is a national symbol from World War II, and in his case was designed to be the threatening face of Nazi Germany. The mask this scheming foe wore was treated very much like a flexible, real face. The question of his real identity was not often focused on, as who was supposed to have been wearing the mask often changed.

Over time, he also became defined as a transformed super-soldier with an actual red skull head, but this too would shift based on the writers and artists doing the telling.

The Cosmic Cube I illustrated him holding was a recurring element of absolute power that would often come into his possession. This all-powerful device was a Jack Kirby creation, just as the Red Skull himself was. Over time, Kirby's work with collaborators Joe Simon and Stan Lee bridged the many ages of Marvel's development and is one of their most celebrated concepts.

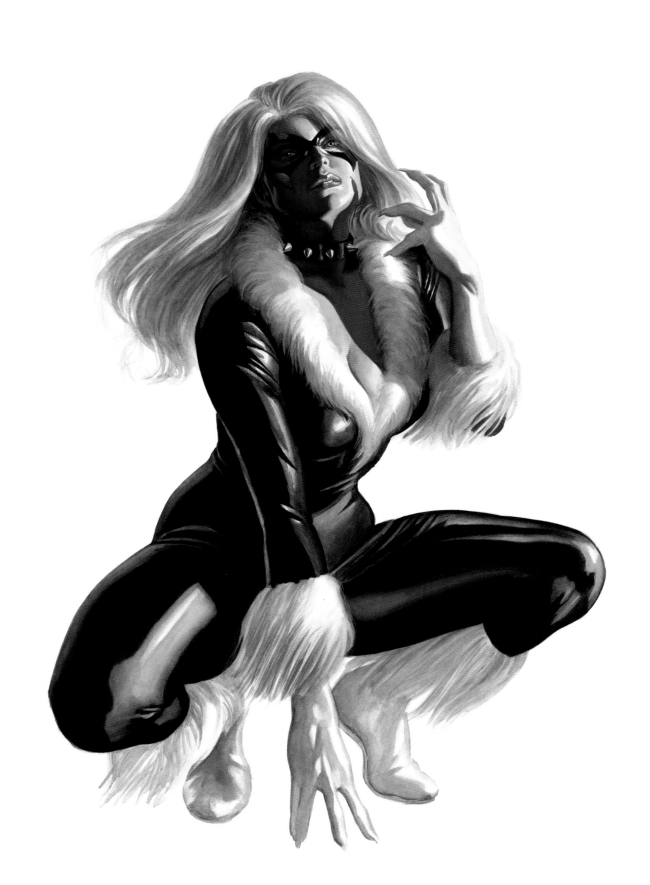

THE BLACK CAT

First developed as a feline thief who was obsessed with Spider-Man but had no interest in the real man underneath the mask, Black Cat was a romantic favorite for readers. She was simply the one you shouldn't fall for and would largely complicate the Wall-Crawler's love life.

Originally designed by artist Dave Cockrum and first drawn by Jim Mooney, the Black Cat made an impression on fans enough to remain a regular criminal presence while being a sympathetic figure. Black Cat gained pinup model status thanks to artwork such as a popular poster painted by artist Joe Jusko in 1986.

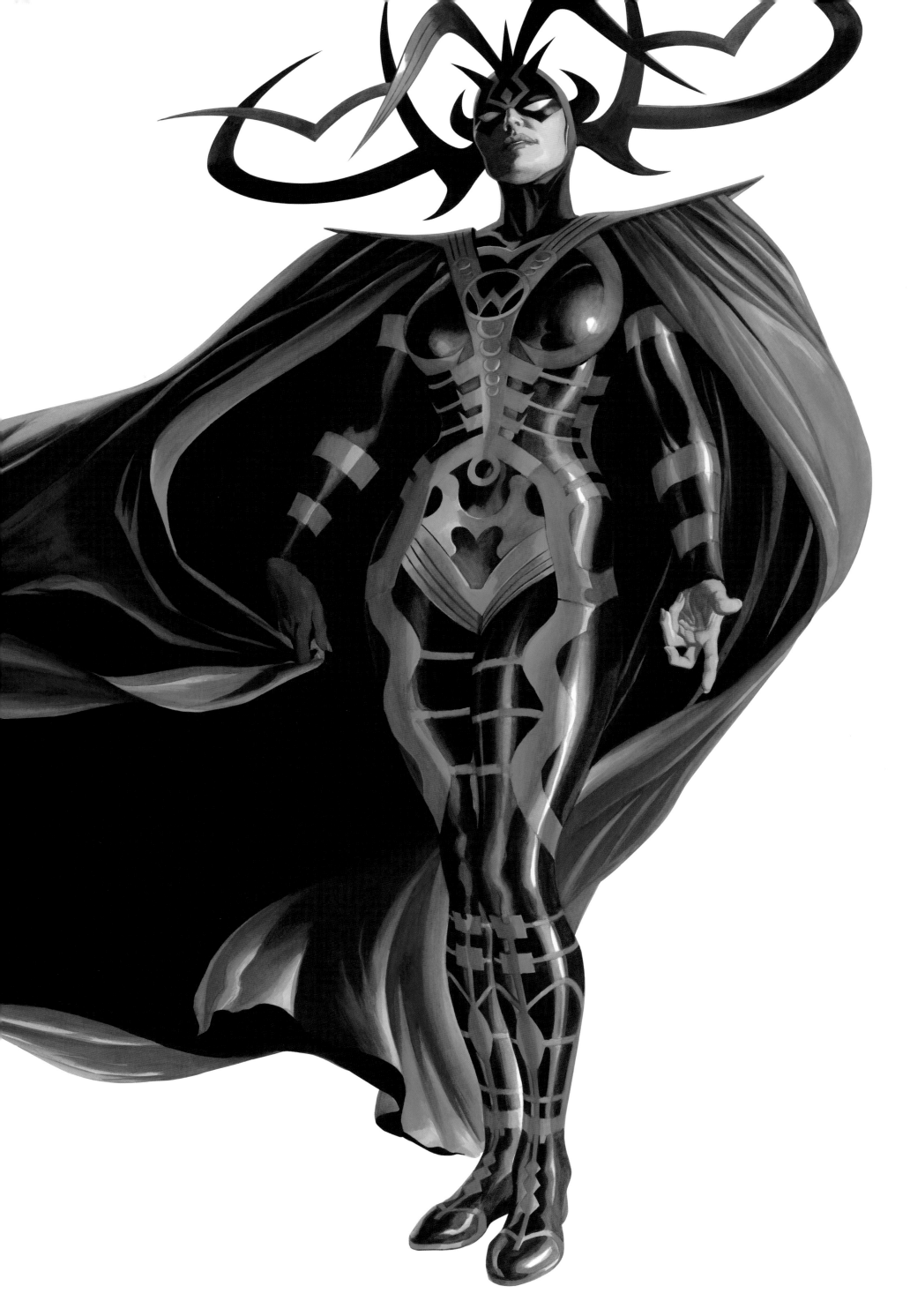

HELA

The Norse queen of the Land of the Dead, Hela is one of the final great character contributions Jack Kirby made in his legendary run on the *Thor* comic. Her complex headdress and dazzlingly detailed costume are hallmarks of Kirby's unique vision. The impressive height of Hela's form was a detail I didn't fully remember until I checked her stats and double-checked her first introduction to see how she towered over Thor.

Altogether, I must admit that most of the women included in this villain lineup are debatably villainous and are largely characters with redeeming qualities.

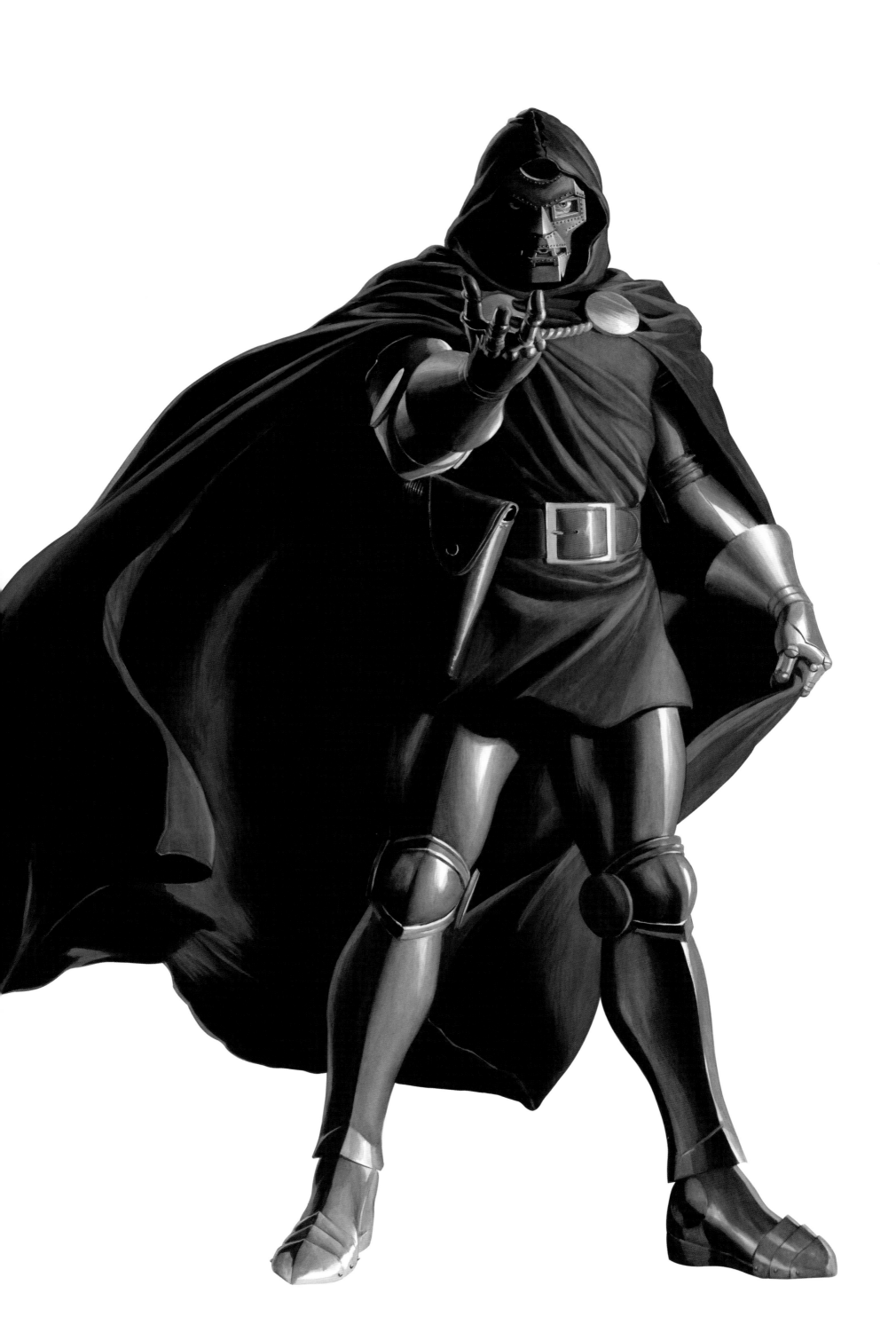

DOCTOR DOOM

Marvel's premier super villain is Doctor Doom. His engrossing story of growing up a poor outcast whose brilliance and ambition guided him to become a monarch of a small country was compellingly told by Stan Lee and Jack Kirby. The fact that the face behind the mask was presumably disfigured made his identity defined by his chosen image of an iron-clad dictator. The iron mask he wore conveyed his personality. His actual name was, in fact, Doom.

The long-standing rivalry between Doom and Mr. Fantastic is one of the driving dramas for all of Marvel Comics and is likely the most important hero-vs.-villain matchup. The fact is that both are scientists whose greatest asset is what they can conceive and how they apply their inventions. The distinct tools that Doctor Doom uses within his powerful armor, or his various robot emissaries, are but a fraction of what his skills are capable of. Doom's long-range goal is world domination and the defeat of the Fantastic Four, which he has experienced the temporary accomplishment of every now and again.

Artistically, my approach to Doom's look is based on a head sculpt by Mike Hill that I art-directed. The features of his classic mask will often get exaggerated by artists to seem like he has a deliberately angry expression sculpted in. The classic shapes in the metal features that Kirby established are boxier in configuration but project plenty of fearsomeness.

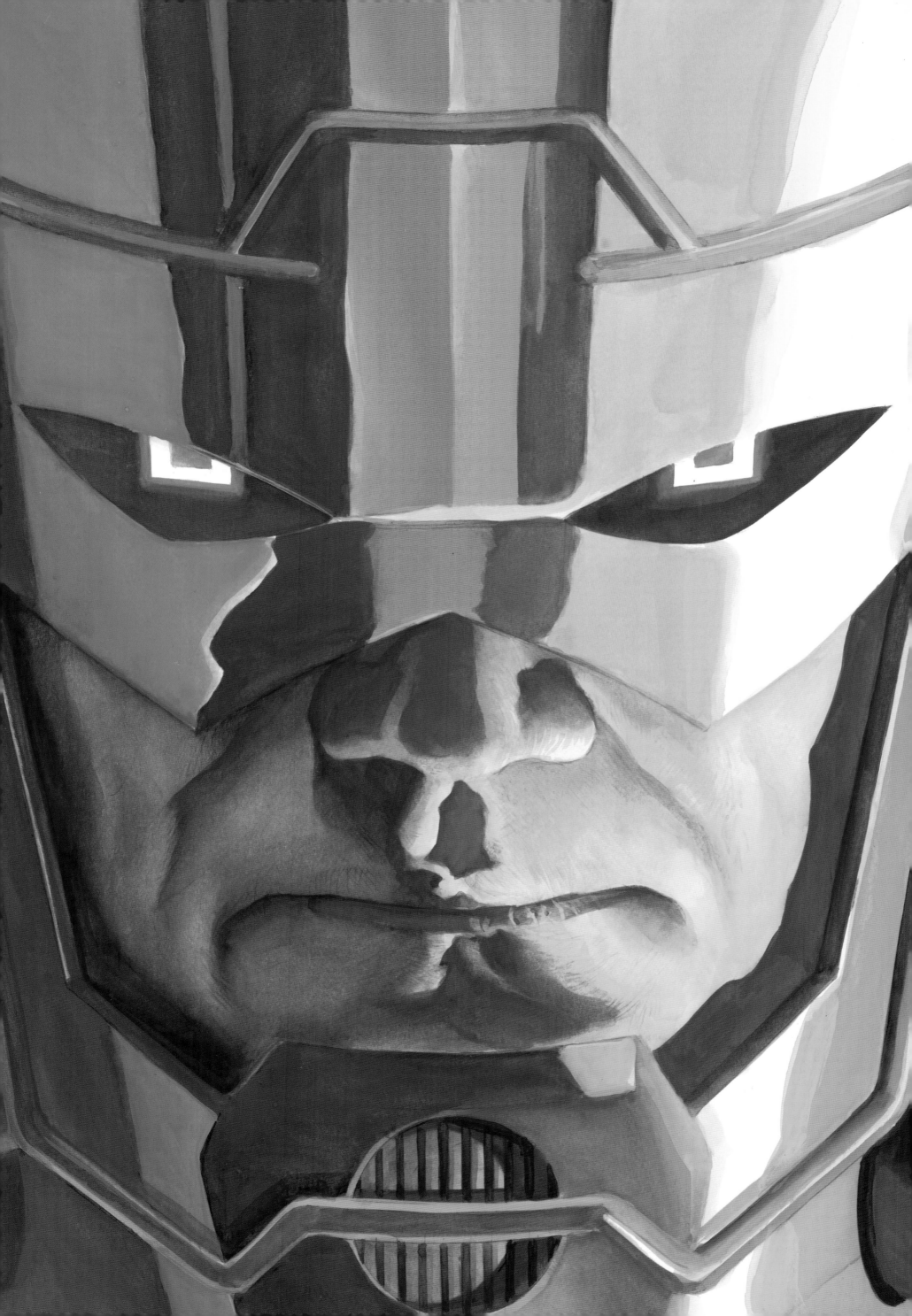

GALACTUS

Generally, the biggest threat in the known Marvel Universe is Galactus, as he shows up often to see if he can get away with absorbing the planet Earth's energies. The first introduction of Galactus and his herald, the Silver Surfer, who preceded his coming to consume our world, is considered one of the greatest stories in comics history. This multi-issue arc was a peak in the collaboration of Stan Lee and Jack Kirby on the *Fantastic Four* book.

The Galactus backstory would prove to inspire more contemplations about the nature of creation after it was established that he came from the universe that existed before ours was born, when the previous one ended in entropic collapse.

Galactus' design as a physical manifestation of God, and as a figure of judgement that must be faced, is one of the most distinctive of Kirby's legacy. Helmet horns are often used by Kirby to establish overwhelming power, as if the wearer has no practical limitations they could be restrained by. The idea of a science fiction "God" is still a radical concept and curious for the fact that it happened at all.

The extra-large depiction in this poster book was meant to reflect his proportional size to the other characters. Galactus' size would grow based on the various interpretations over the years and would also be defined as a changeable state based on how much energy he absorbed from the planets he ate.

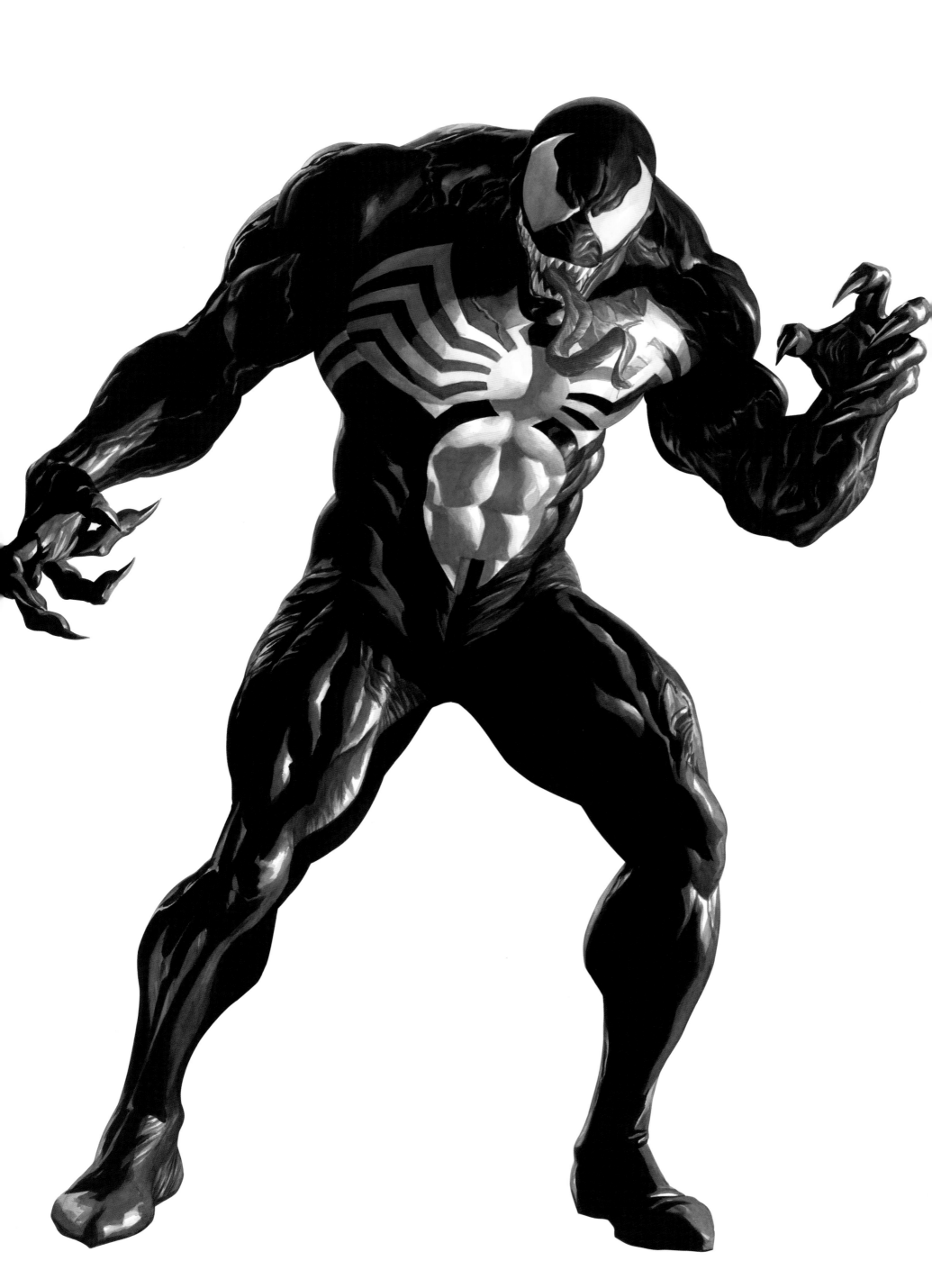

VENOM

The result of Spider-Man getting a mid-eighties costume change meant that the new, sleek black outfit would become its own character. What this approach essentially allows for is the simple counterpart-villain archetype who has a similar appearance and abilities to the hero. In the case of Venom, he may have started that way, but creators David Michelinie and Todd McFarlane took it in another direction. The revelation that the alien costume Spider-Man found was actually a sentient thing that lived off him symbiotically launched a whole new basis for an enemy. With the costume exerting its sentience, this would lead to a shared personality for the next wearer to balance.

Venom also amplified his size over time to be larger than its next wearer, who himself was bigger than Spidey, with the new form approaching Hulk-size proportions. Venom's bulk seemed to grow in proportion to his popularity. His nature as a symbiote would launch other beings of the same origin, making a whole new category of threats. The complex motivations of the human and alien's shared life led to Venom becoming more of an antihero, enjoying solo superstar status.

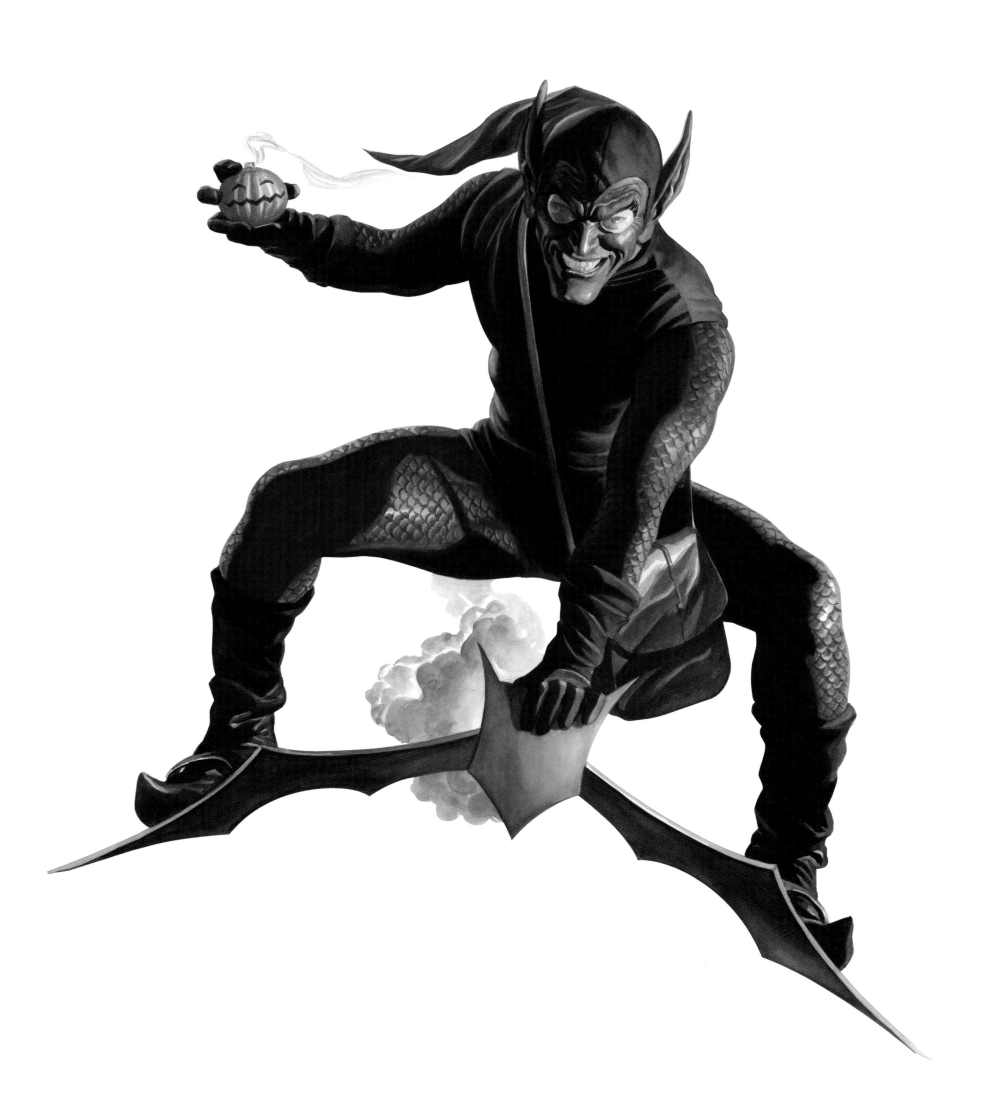

GREEN GOBLIN

For a character who has such sizable notoriety, it's amazing how much of his history has the Green Goblin missing or dead. Ever since his identity as Peter Parker/Spider-Man's best friend's father was established, he had his villain alter ego subverted in his mind. And once it came back for the last time, he got himself killed. Later, the original Green Goblin's son would take up the mantle, and the same dual personalities would lead to periods of the bad guy being subverted again.

In reality, there is more time in the Goblin's legacy that he was only present as an existential threat than an active player Spider-Man would have to face, which speaks to the power of his creation.

In other media and merchandise, the Green Goblin is possibly the most well-known Marvel villain. His colorful, cackling image was an infectious design that Steve Ditko created with the intent to have an adversary for Spidey that he could never seem to beat. Stan Lee's direction that the villain was quite close to Spider-Man's life was a dramatic turn that does strain plausibility but crafted one of the most stimulating dramas in comics history.

The Goblin's eventual killing of Peter Parker's girlfriend, Gwen Stacy, would establish a dark legend that affected readers for ages and made the villain an unnerving figure.

My work on this piece, like others I've done of him, is based on a sculpt by Mike Hill that I designed.

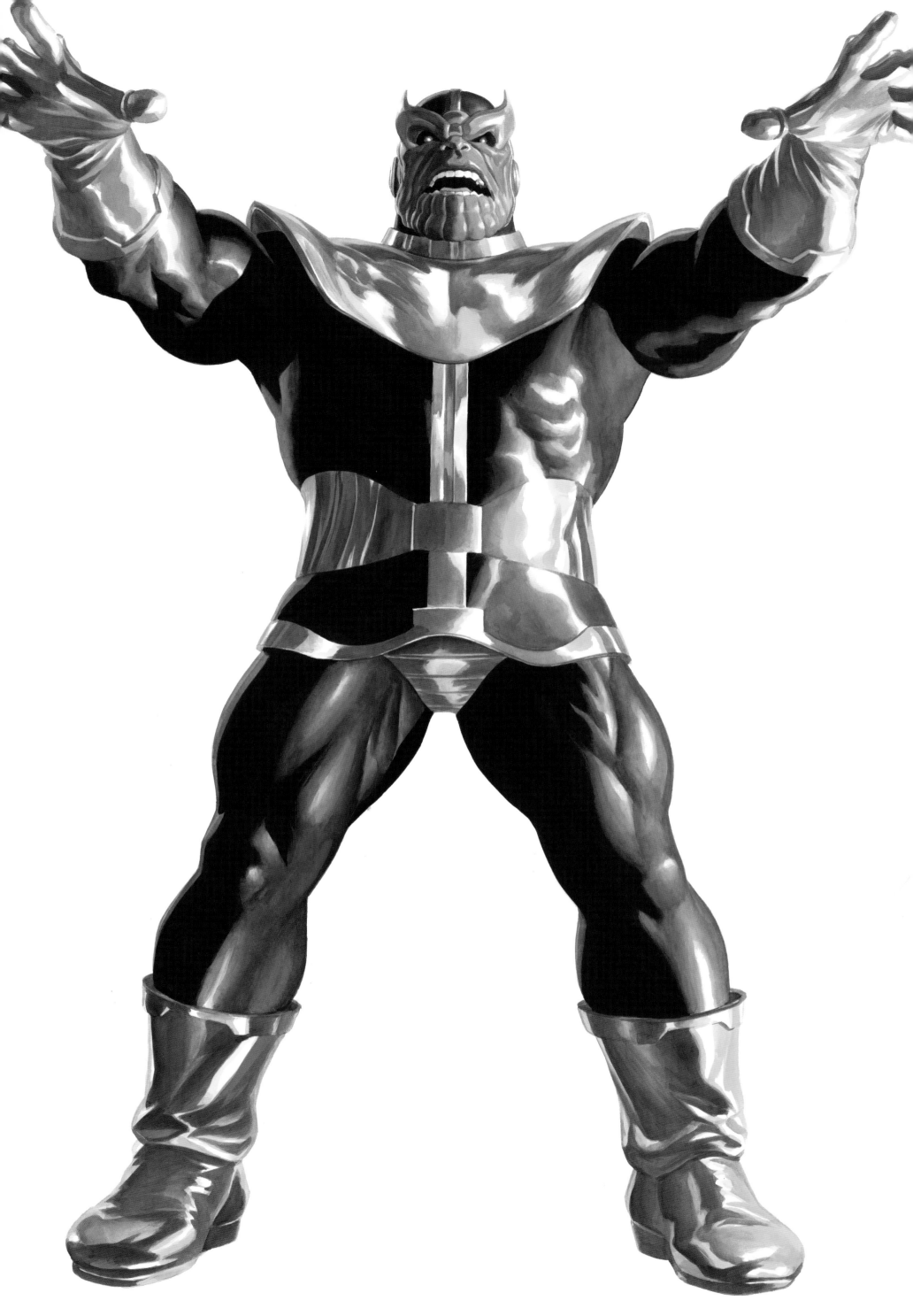

THANOS

The pose selected for this portrait is taken from the moment in the character's history that left the greatest impression on me. Because Thanos came to his end (originally) just before I started reading comics, I wouldn't encounter him until he was making an appearance in the 1982 graphic novel by Jim Starlin, *The Death of Captain Marvel*, where he was still dead himself. In the story, we see a frozen stone statue form of the late Thanos that has been left behind. This is the pose I illustrated. Thanos' use in the tale is to reach the dying Captain Marvel in his final moments to offer him revelations of his fate and to help him accept it. The villainous history and actions of Thanos are in the past; however, his afterlife form, while still menacing, is helping the hero, and us, to move on. This graphic novel was one of my favorite reading experiences, and Jim Starlin, Thanos' creator, was inspirational in showing the heightened levels of meaning to be sought in comics.

Sometime later, Starlin brought Thanos back from the dead, and he has become a recurring threat in stories for the last thirty years. The level of recognition for this villain has been raised through the movies to become one of the most well-known of all Marvel properties. Still, his greatest impression on me was when he broke from the traditional role he had and showed a level of maturity beyond his earlier ambitions.

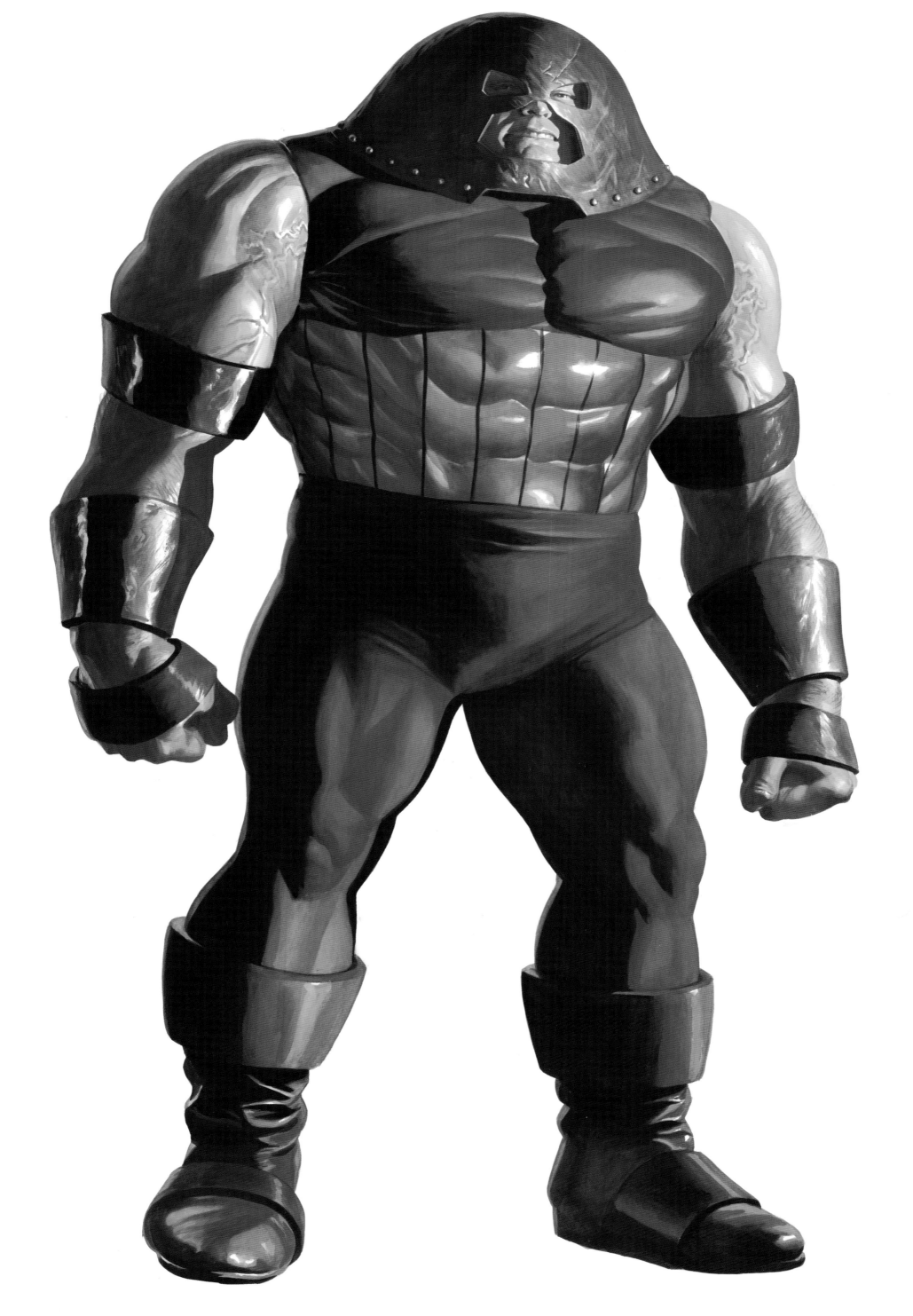

THE JUGGERNAUT

Another distinctive villain design that Jack Kirby contributed to a book he was largely moving on from, the Juggernaut would be one more key villain for the X-Men and the Marvel Universe as a whole. The idea of his being an unstoppable force to face off against would pair Juggernaut with virtually everybody else at Marvel. The subplot of Professor X's non-mutant stepbrother, who became empowered by a magic gem and entity, set up another part of the endlessly complex family relations for the X-Men mythology.

As another Hulk-size Kirby character, Jack uses the aesthetics to amplify this enhanced antagonist with a bolted-on headpiece that blended with his shoulders, and taut armbands that emphasized his girth. Characters of this bulk always provided Kirby new challenges of how to vary their looks.

THE MOLE MAN

Being the first villain for the Fantastic Four from their history-making first issue makes the Mole Man a beloved oddball adversary. Supported by his unique subterranean-dwelling mole men and an endless variety of giant monsters, this sightless villain was a societal reject who embodied resentment. His features and stature help establish a character who has thankfully not been idealized radically over the years. Jack Kirby's subtle shape designs with Mole Man's glasses (or the mole men's eyes) made his otherwise simple clothes reflect the Kirby age of design that would guide comics for years to come.

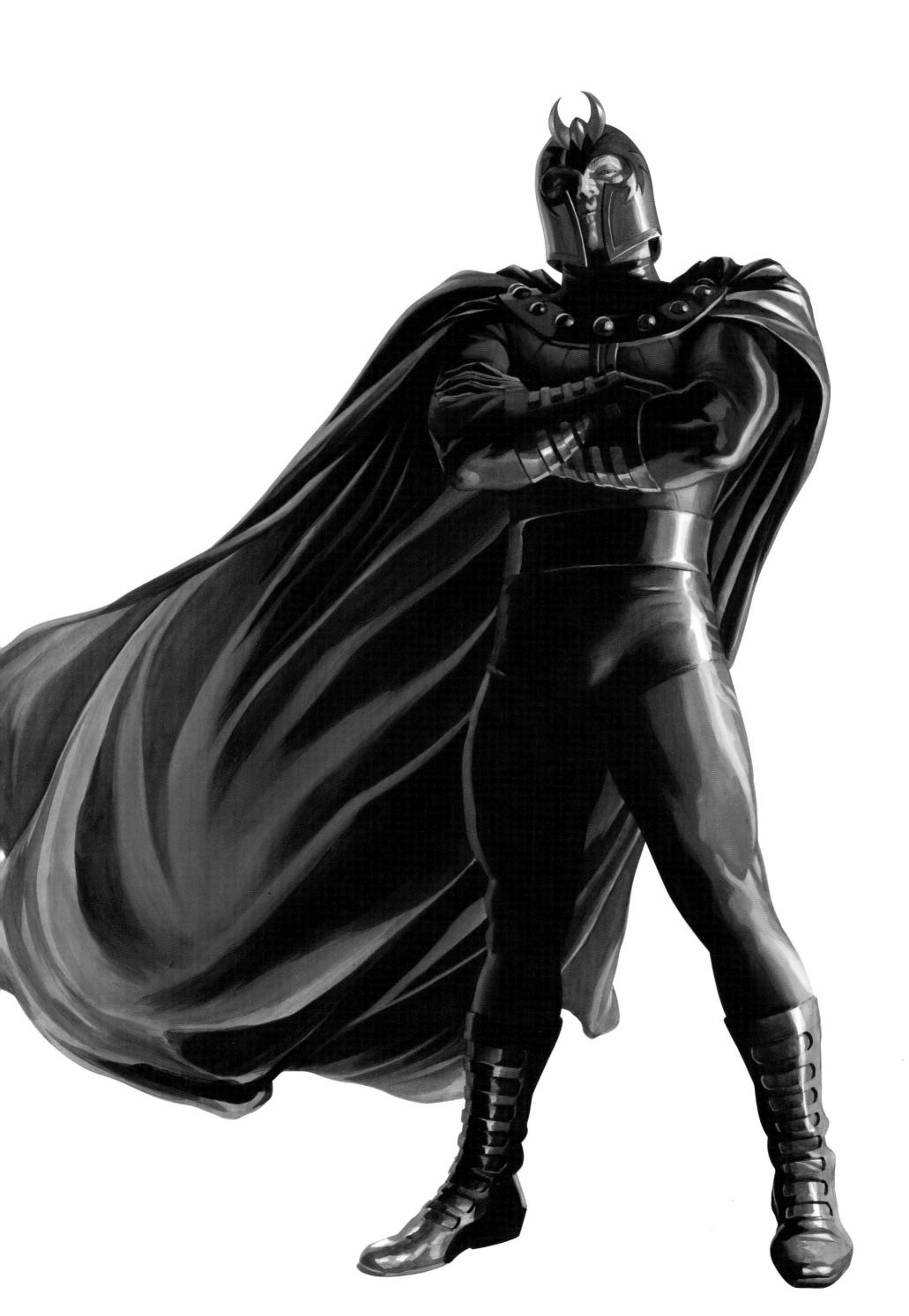

MAGNETO

The combination of electricity-like edging and bolt shapes with stylized horns and traditional devil costuming shouldn't have worked as well as it does, but it works quite well. The way of many popular villains is that they evolve to antihero status and possible redemption. Magneto's introduction in the first issue of *X-Men* was with a standard world-threatening ambition and very little of the lifetime of persecution that followed mutants informing his character. The greater background Magneto had of being a Holocaust survivor and the father of other mutants was all part of the rich history that would be developed to make him more compelling and sympathetic. Writer Chris Claremont would add to the depth of what creators Stan Lee and Jack Kirby left behind. The extensive use of Magneto's appearance in films through this century established him as a world-known, complicated antagonist. Few characters ever get the amount of creative development Magneto has over the years.

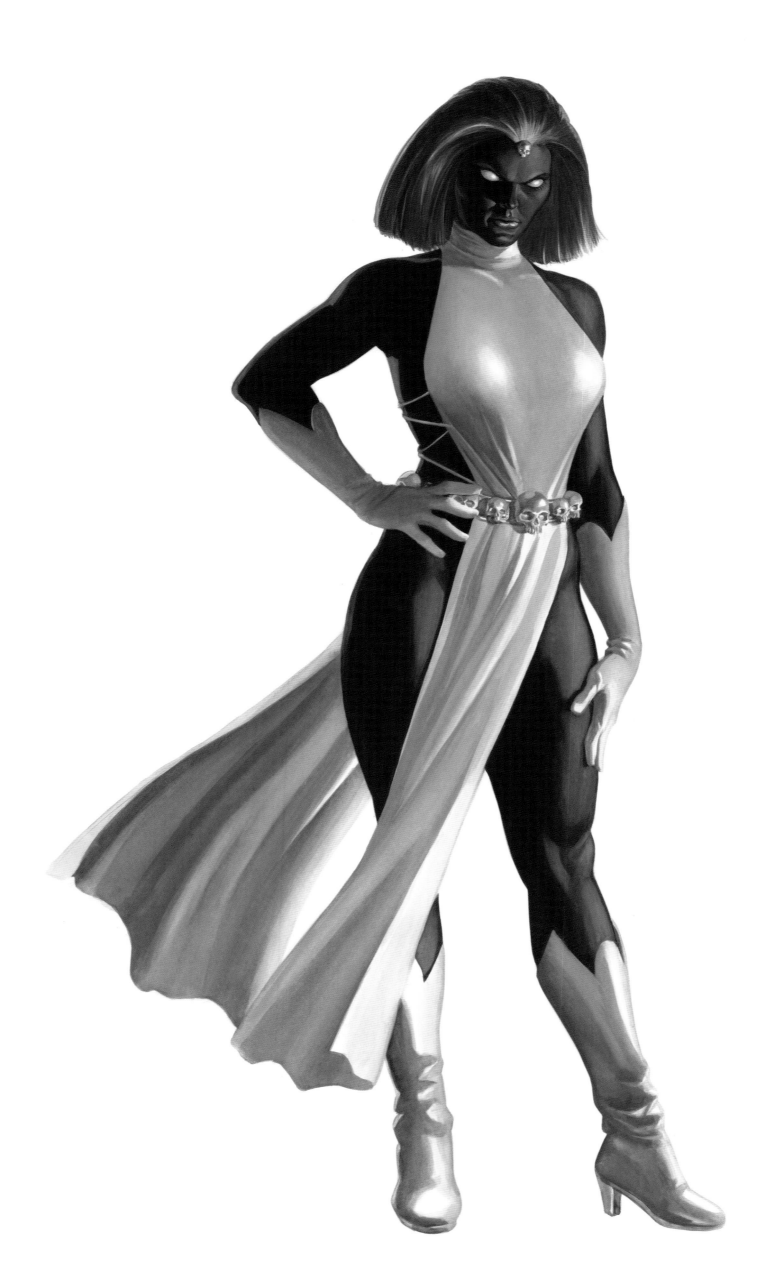

MYSTIQUE

This distinctive design by Dave Cockrum was drafted into use for a new leader of the Brotherhood of Evil Mutants (taking over for Magneto) by artist John Byrne, who introduced the shape-changing mutant with writer Chris Claremont. As Mystique originally appeared in print, her skin was a dark navy-blue color that was uncommon for most designs at that time. The elegant dress, boots, and gloves she wore are part of the excellent legacy of the chief "New" X-Men designer/co-creator Dave Cockrum. Despite her history as an assassin, she is another antihero for readers drawn to her position in defense of her fellow mutants.

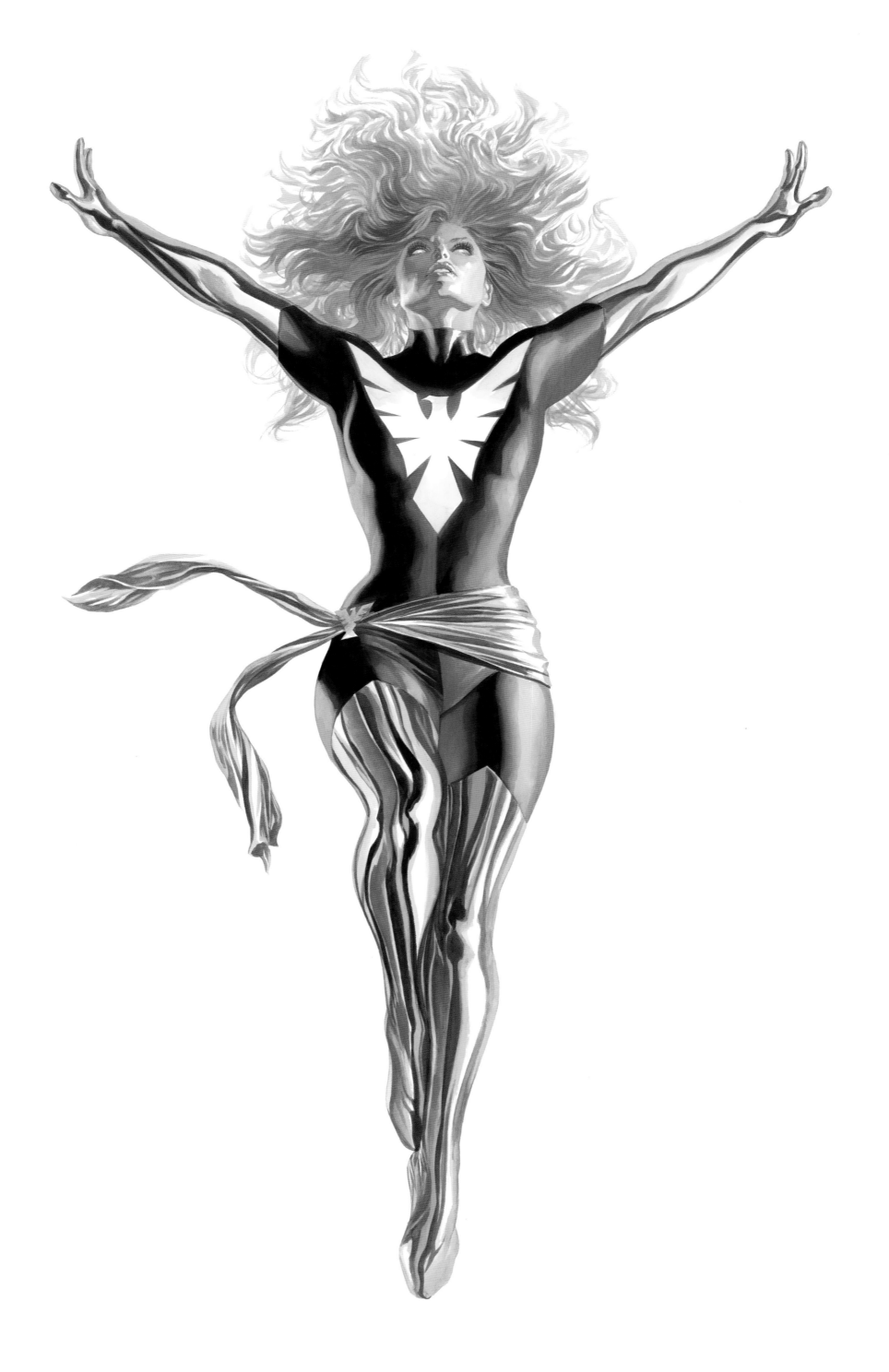

DARK PHOENIX

Only one character with split identities appears in both mural projects I've done of Marvel's heroes and villains: Phoenix and Dark Phoenix. When Jean Grey held her original identity as Marvel Girl, she wasn't largely seen as the X-Men's most impressive member. Chris Claremont and Dave Cockrum rebuilt her as the most powerful X-Man when she seemingly died while protecting the team and, by some presumed cosmic forces, emerged as the Phoenix, reflecting the legend of the mythical creature.

Years after her rebirth, John Byrne and Claremont put her through a subversion of her personality and dignity when she was pulled into the Hellfire Club, eventually tapping into her dark side—the murderous, godlike Dark Phoenix.

The storyline that led to her eventual destruction is considered one of the greatest in comics lore from one of the most celebrated creative teams and eras of the medium. The gentle spirit of Jean Grey's original form was the construction of Stan Lee and Jack Kirby, but the greater use of her as a character was to represent the evolution symbolized by the mutant concept in the *X-Men* book.

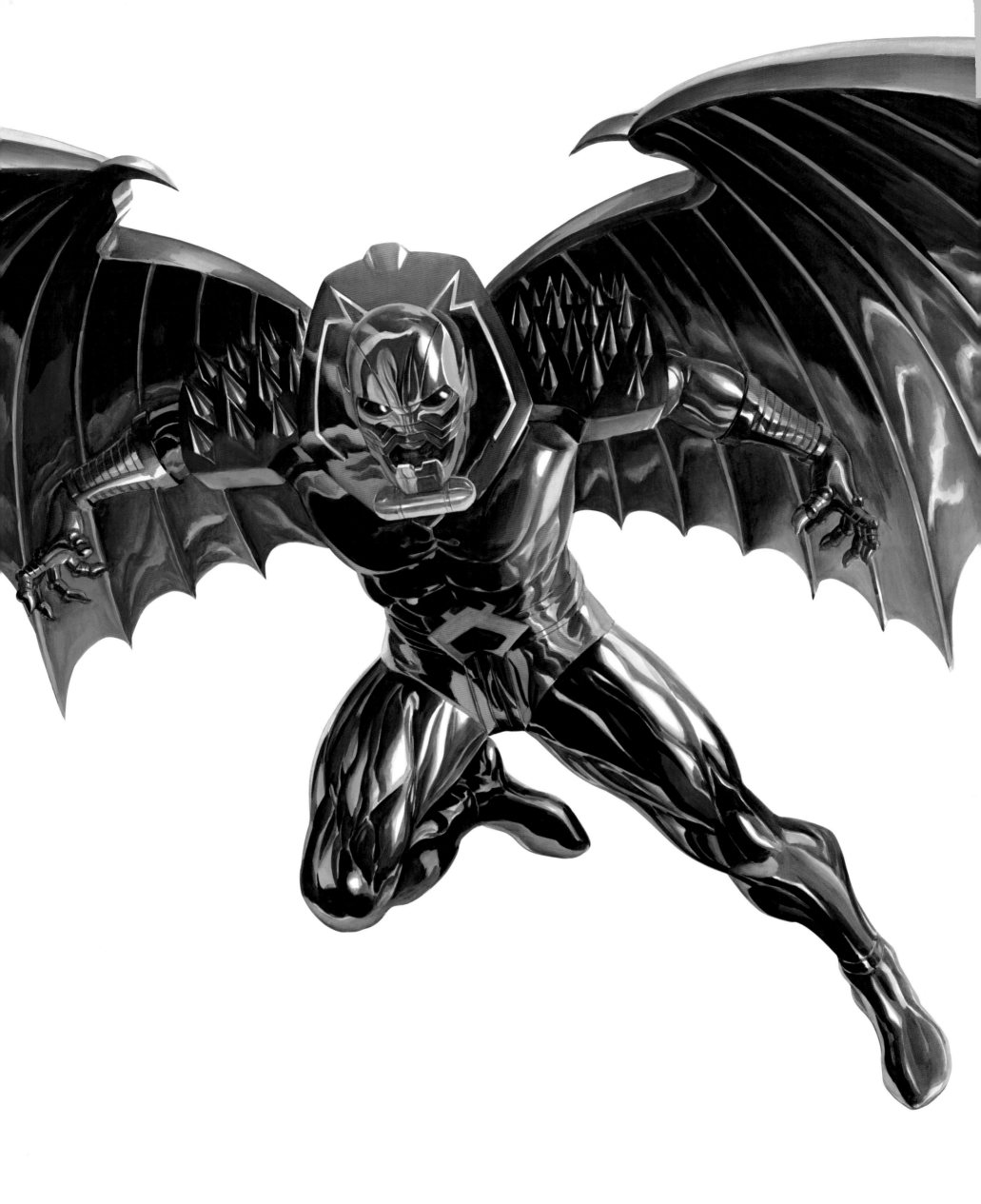

ANNIHILUS

One of the great designs that embellished the wider worlds discovered within the Fantastic Four comic was the insectoid tyrant from the Negative Zone, Annihilus. His distinctive and stylish bug-like armor reads as alien in a way that expanded how readers would come to understand that there is more to encounter in the universe with others who don't quite look human like us. The Negative Zone was an interesting abstract space that would indulge Jack Kirby's collage art and penchant for inhuman creature craft.

Annihilus would be a recurring foil for the FF whenever they entered the Zone, and he would make his way to their dimension as well. His threat was meant to signal that more alien life would follow him into our world as he exerted control over the other life forms from the Negative Zone.

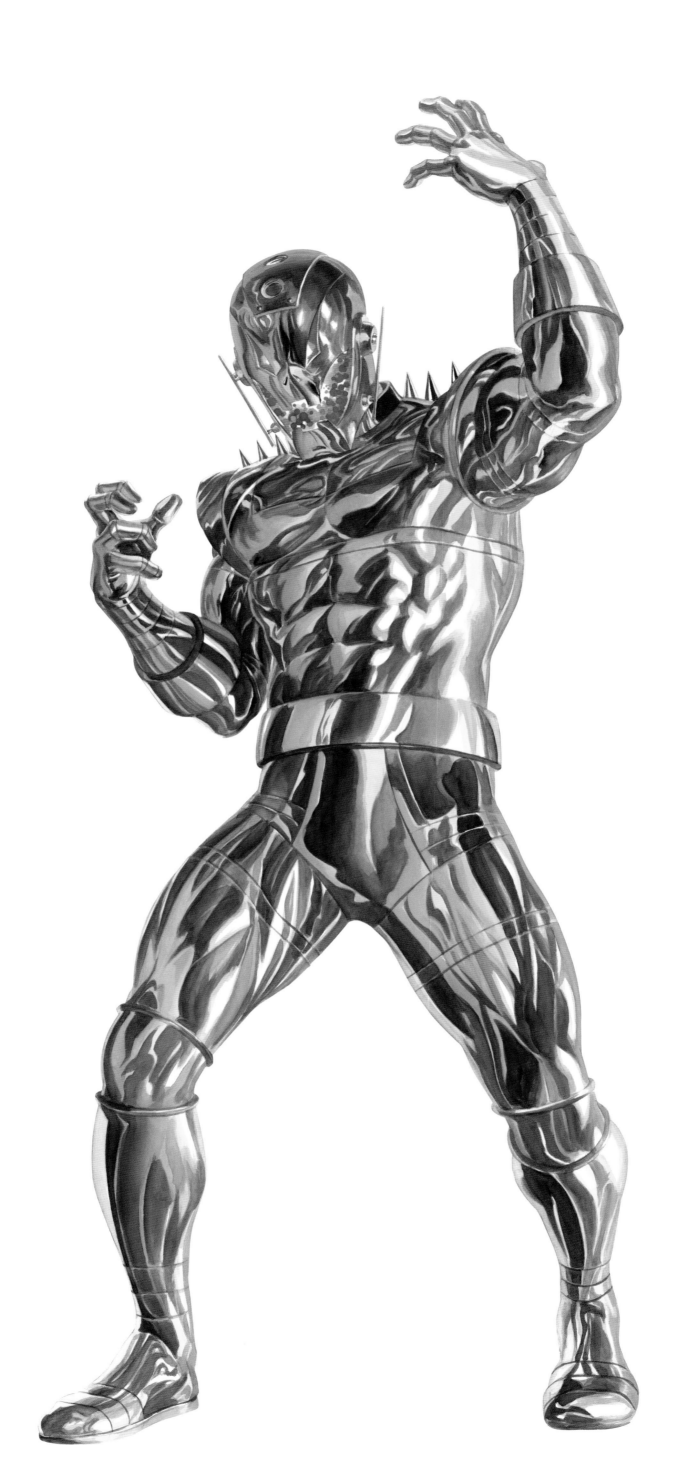

ULTRON

The creation of Ultron by Roy Thomas and John Buscema comes from what I would consider the greatest period of Avengers comics, and Ultron would become one of the greatest adversaries for the team. His ability to revise his own construction is the result of his unique quality as an artificial life form. The angular and inhuman features of his face shell made an impression of his being beyond his human-built origins. He seemed scary.

Ultron's creation of the Vision was a key part of comics history that would be enough to keep him relevant, as that story is often held up as one of the medium's best. Ultron would constantly return with more bodies to plague the Avengers. As the invention of Dr. Hank Pym (Ant-Man/Giant-Man/Goliath/Yellowjacket), he serves as a reminder of the dangers the Avengers unwittingly bring into the world.

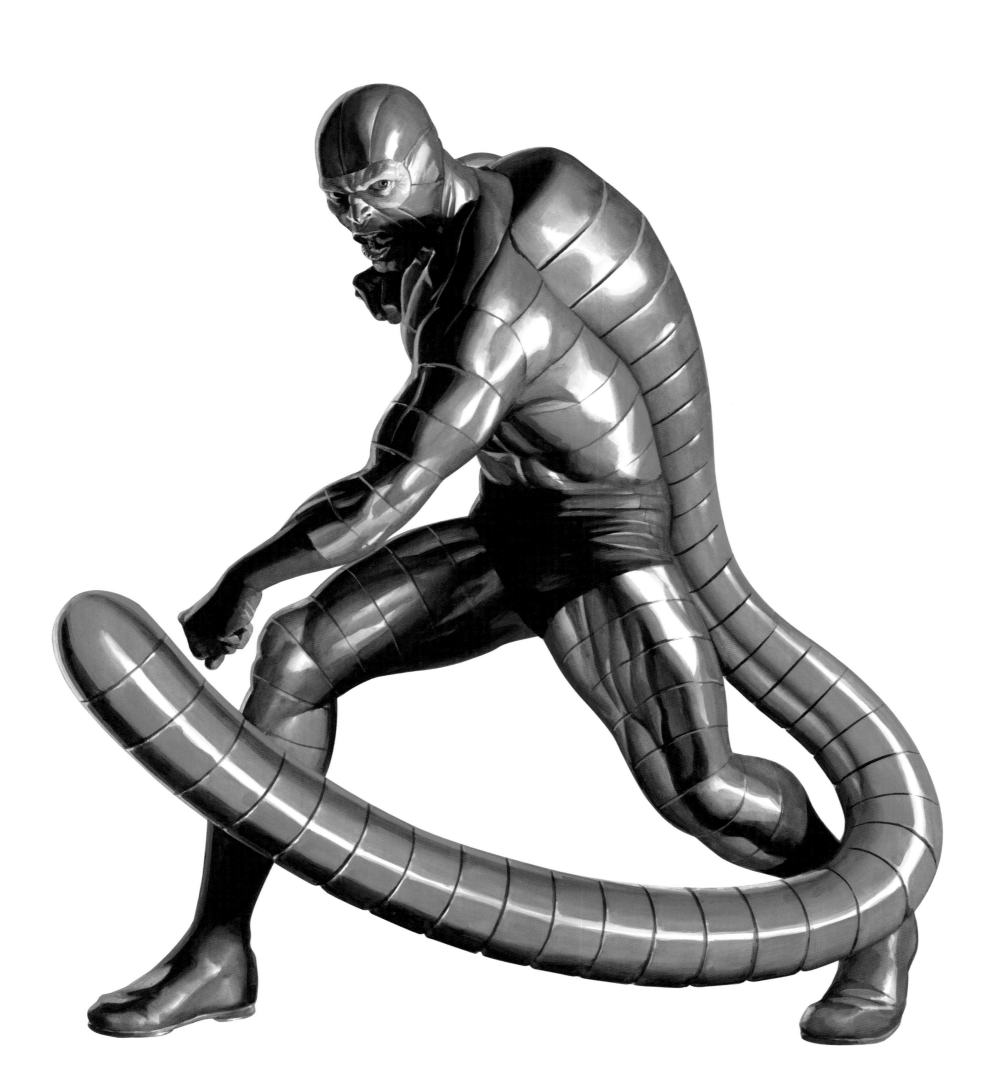

SCORPION

Continuing the tradition of great Steve Ditko designs for Spider-Man villains who were colored green, the Scorpion is a great adaptation of the arachnid it was based on. The nature of a man sealed up in a costume that he could never escape was enhanced by the reverse mask effect where only his eyes and the domino mask area around them are exposed. Seeing his nose and mouth covered in this costume armor that acted as a second skin is a bit unnerving when one considers it is never coming off.

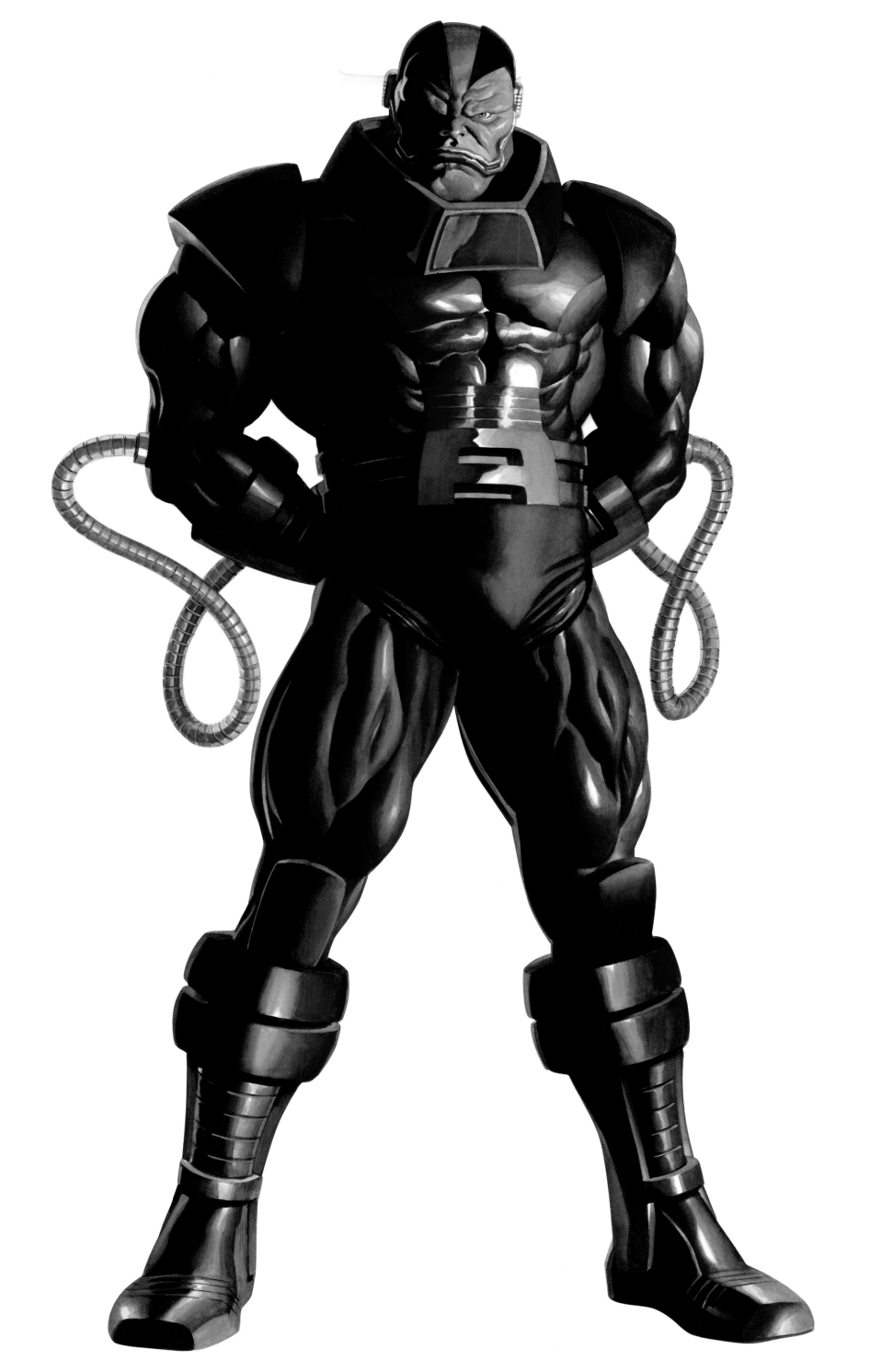

APOCALYPSE

The ancient forerunner of the mutants always threw me as a graphic design and as a concept. Apocalypse comes from the period of artist/writer Walter Simonson's work with the original X-Men reunited under the new team name X-Factor. Apocalypse had his own self-styled four horsemen, for which he rebirthed a wounded Angel into the angel of death, Archangel. Nothing in X-Men continuity would ever be quite the same again with this change.

Apocalypse has a somewhat exaggerated figure that reflects the distinctive style of his creator. I have never attempted to illustrate him myself until this portrait, for which I tried to capture his shape and Simonson-style features.

The history of Apocalypse sets his origins back to Egyptian times as a force felt even then. I have always been stuck on how mutants were largely a post-Atomic Age evolution of humankind, the result of increased radiation levels throughout the world. This would not be true in the deep past, but Apocalypse's full origins have been recently revealed to be from beyond this plane of existence, so it works.

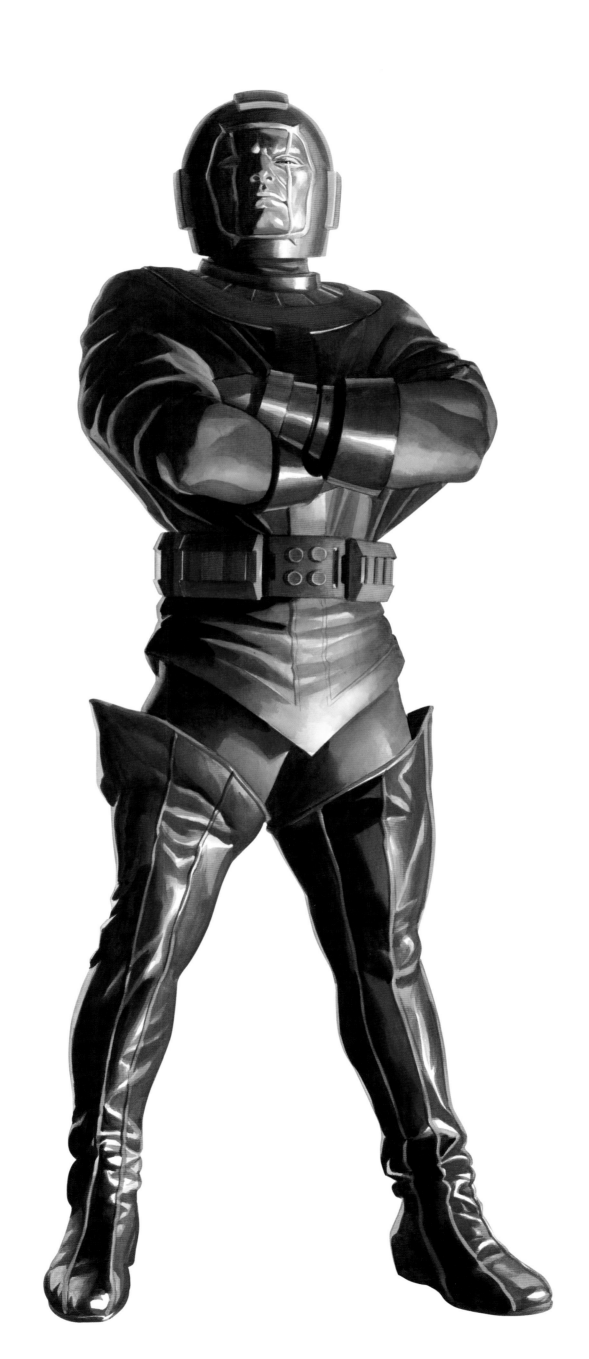

KANG

A favorite character of mine to point out Jack Kirby's unique sense of costume design is Kang. His look could have gone a million different ways to visualize a time-traveling despot, but each choice Kirby made was so unusual and not obviously based on the preceding science-fiction villains of that type. The tall, loose-fitting thigh-high boots are rendered very practically and not skintight. They have a grandiose flourish, but not the same as another high-collared cape would have been. The tunic that pulls from the belt center wasn't an obvious choice but feels regal. The helmet, with a pasted-over mask that seems to mirror the features behind it, is an odd element that blurs the line between his real face and mask. One could be confused as to whether the mask was painted or a completely misleading facial structure.

Kang's identity would become defined over time as shared with other time-traveling characters like Immortus, establishing that they are the same person from divergent time periods. Kang's hostile recurrence as a foe for the Avengers kept him at the forefront of his historical variants. He remains one of the villains whose armada and armory should make him undefeatable; except, of course, he does always lose when he shows up. Otherwise, we'd have no stories for our heroes if he won.

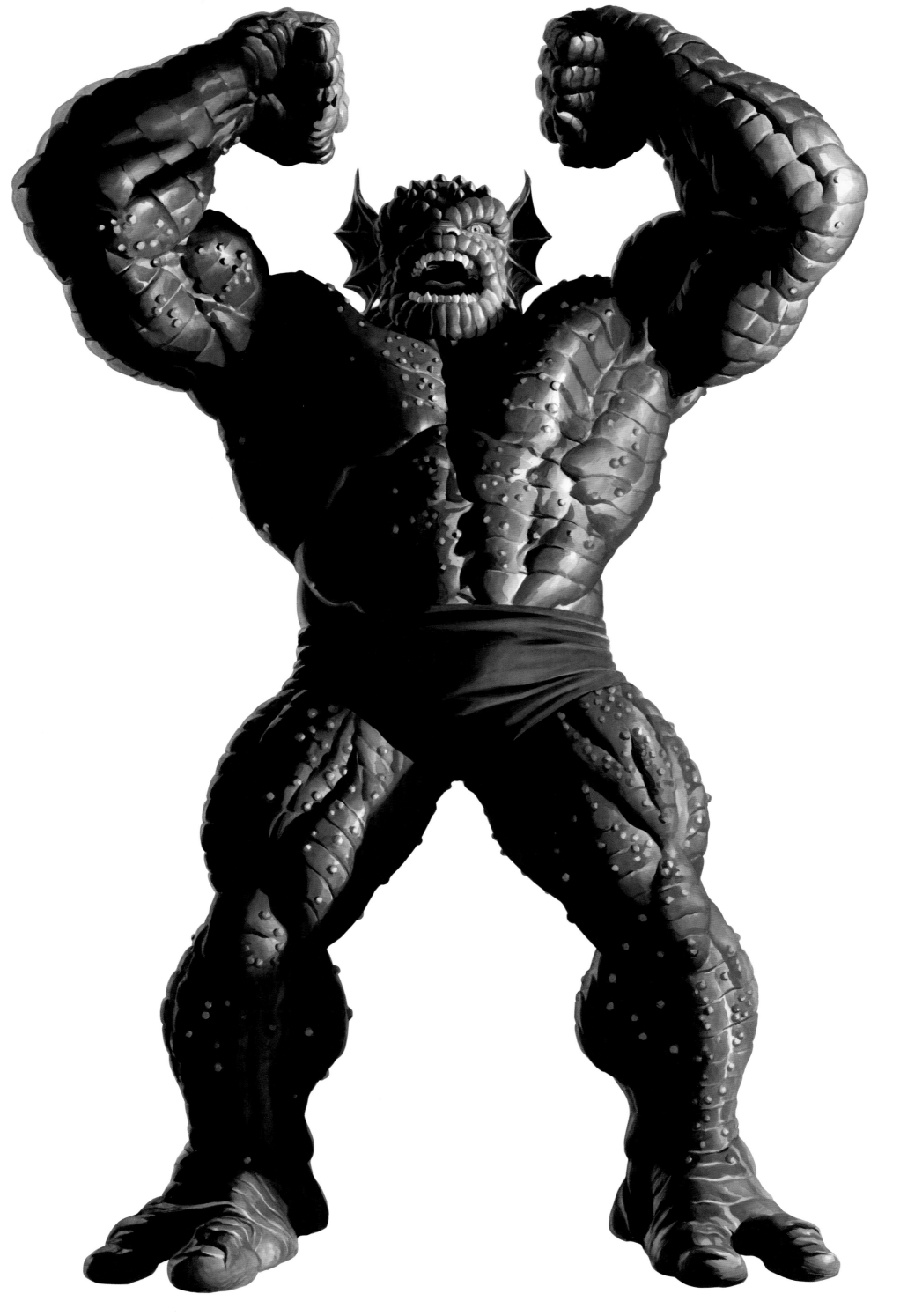

ABOMINATION

Weirdly, if I had to think of an ultimate bad guy for the Hulk, it would have to be the Abomination, even though his stories haven't made him an epic threat outside of being a bad-guy Hulk. The role he fulfills is as an uglier mutation from gamma rays, with an uglier nature compared to the man himself. The look designed by story artist Gil Kane featured a mildly reptilian take on the Hulk, with amphibian attributes as well. He has a kind of multispecies monster mix.

The Abomination also embodies the standard for virtually every other gamma-infused creation in that they keep their basic intelligence and personality. This would seem to be more of a way to not sympathize with our gamma-villains, allowing them to have an edge over the Hulk, given his compromised mindset. It also could seem sadder to establish two mentally modified adversaries who would appear more like fighting children. This idea gives the better notion to leaving only the Hulk seeming like the embattled innocent.

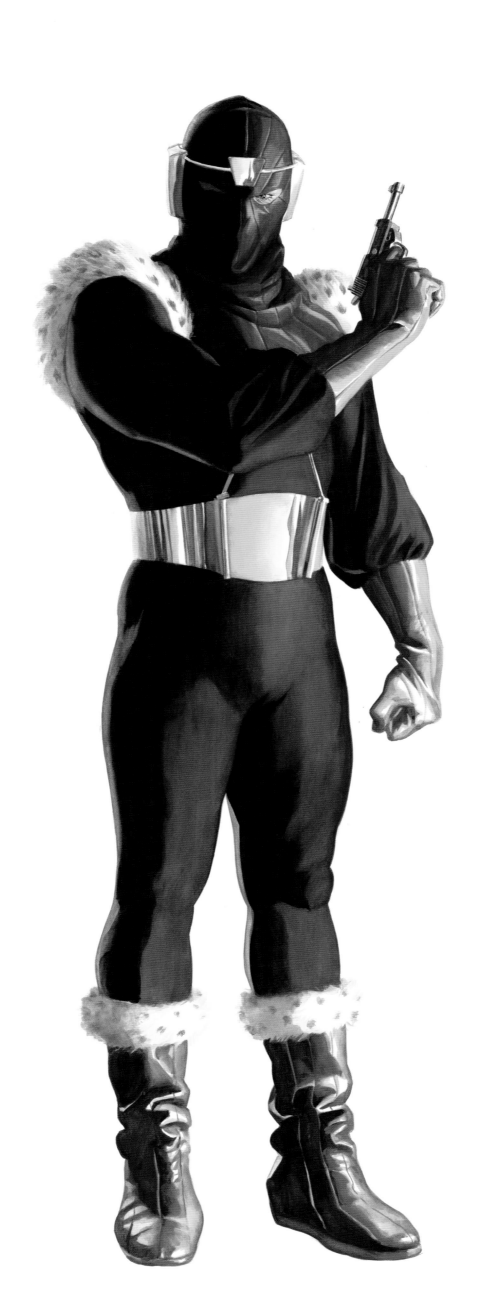

BARON ZEMO

Oddly, I expected when I researched the villain Baron Zemo that I would find his father to have been the bigger legend and embodiment of this identity. The German villain Baron Zemo was retroactively placed in Cap's past as the one responsible for the bomb that Bucky Barnes died upon, which also sent Cap into the ocean and subsequently into suspended animation. In historical placement, he has a lot of years to have been around, except he really wasn't. It turns out the character whom Captain America fought when he returned from the 1940s to fight in the Avengers books would only exist for a few appearances and be killed off quite quickly. Moving forward to when his son was introduced as the onetime identity of "the Phoenix" (prior to Jean Grey's adopting the name), he would return as his father's true inheritor—scarred face and magenta-striped mask and all. The second Baron Zemo has had far more life as that character than his legendary father, but since it was the dad who screwed up Captain America's life so thoroughly, it has always seemed that the second Zemo was just filling in. Originally, there was no Zemo who killed Bucky and dislodged Cap in the 1940s. They were in publication throughout the decade and even appeared in the 1950s, but since Jack Kirby, their original co-creator, made this revision, it is largely held as the story of record.

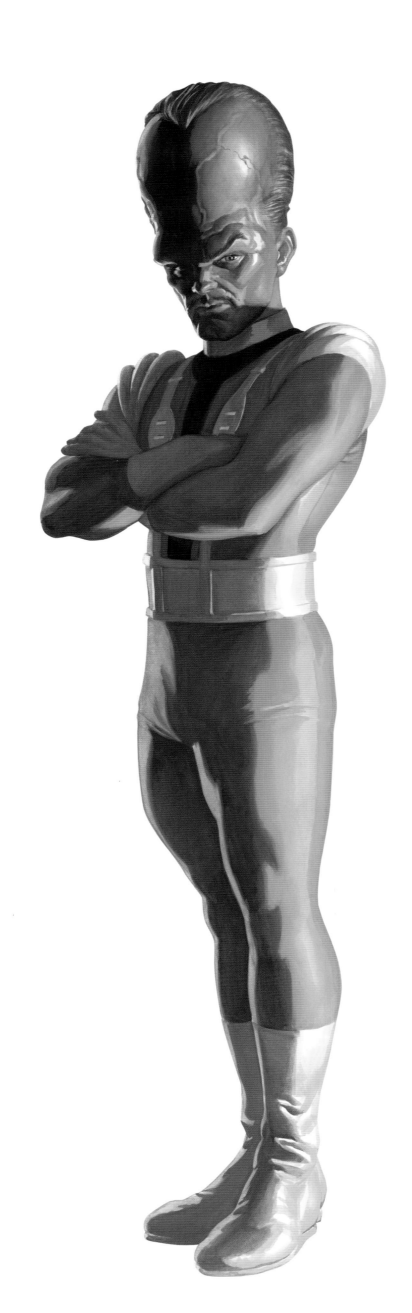

THE LEADER

The villain for the Hulk to flip the script on how gamma mutation might change a person is the Leader. The fact that his double-height head makes for a striking appearance as opposed to being a silly one is probably due to Jack Kirby's design work, from a period where he only contributed layouts to his Hulk stories instead of full pencils.

The era of multiple post-Atomic-Age-grown adversaries who come to bedevil the Hulk was in full swing by the point when the Leader arrived. Using the power of the mind as a counter to the traditional brawn in Hulk's stories was a welcome change. The Leader was modified for more unsettling augmentation over time, but his original appearance was clearly making the point he was made for: to show what an extra helping of brains can get you.

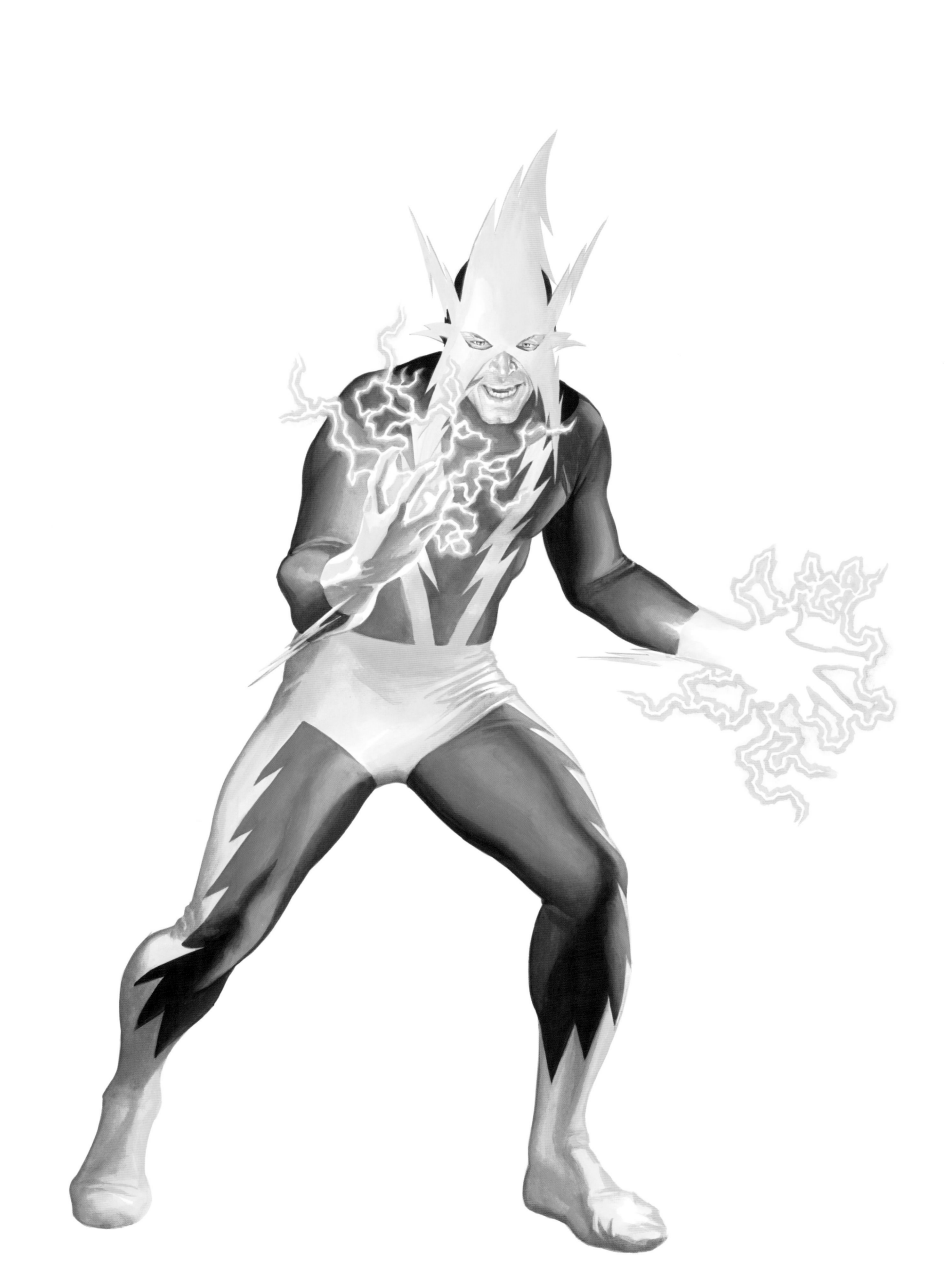

ELECTRO

Electro is one of my favorite outrageously costumed characters. The halo of lightning bolts coming from his mask makes it hard for Hollywood to consider copying that detail when they've adapted him to film, but that is exactly the kind of thing that makes him fun and memorable. When the power-line repairman, Maxwell "Max" Dillon, has an accident that would grant him electrical powers to start his life of crime, he decides to do so with panache. It's more enjoyable to have a flamboyant design—and a green-and-yellow costume—just in case you're paired against Spider-Man. The visualization of Electro counts as yet another Steve Ditko creation who can never be fully improved upon.

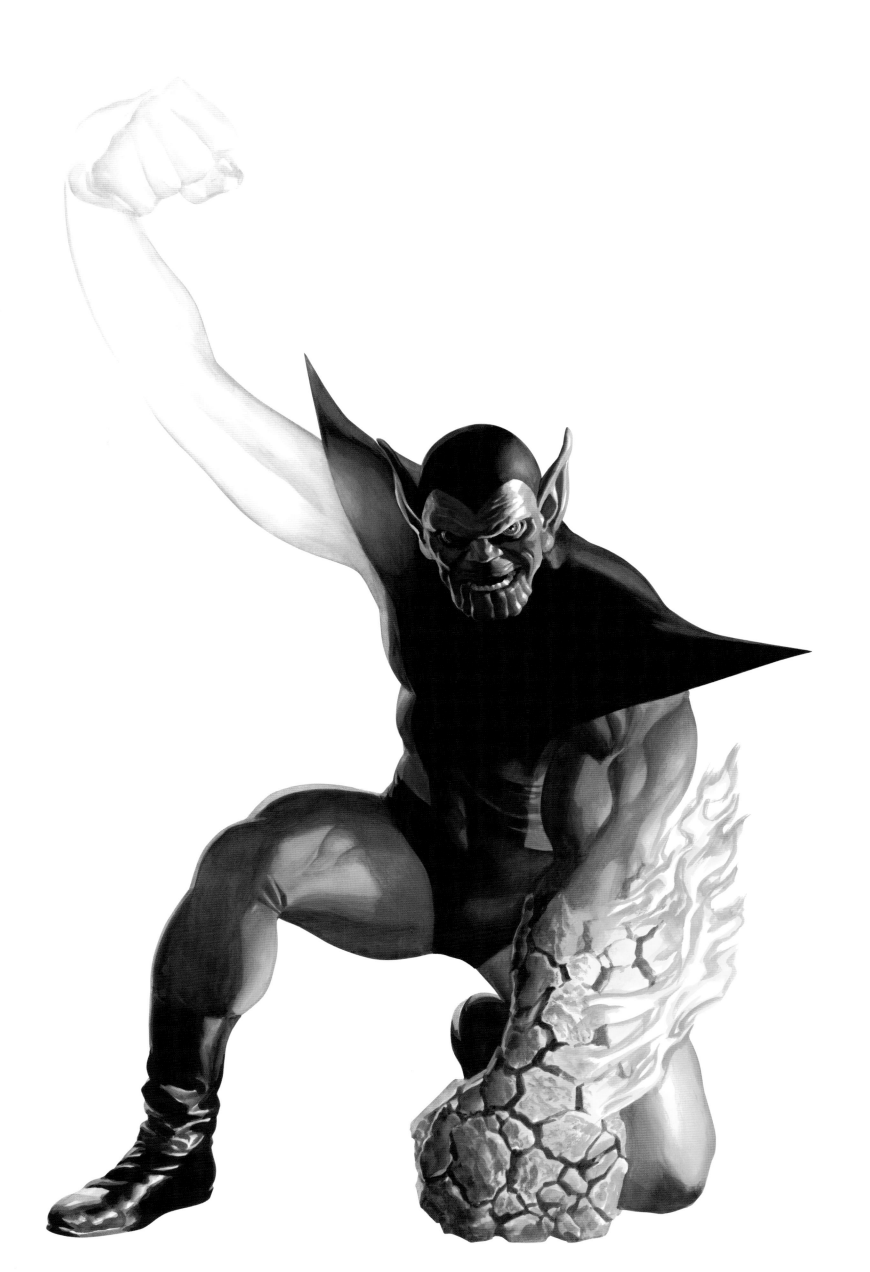

THE SUPER-SKRULL

Of the similar-appearing Skrull soldiers, one was introduced by Lee and Kirby who stood apart. The Super-Skrull was their apex soldier, since he could simultaneously mimic the abilities of the full Fantastic Four, unlike other Skrulls who could only masquerade as one person at a time. This Super-Skrull would appear to be bulkier than most of his brethren.

The traditional pointy-eared green aliens were uniquely rendered and made distinctive through the facial structures and costuming that Jack Kirby gave them. The Super-Skrull was a step in the direction of greater individual focus for a mostly interchangeable race.